FLOWER EMBROIDERY

Over 100 floral motifs and projects to create

SUSIE JOHNS

CONTENTS

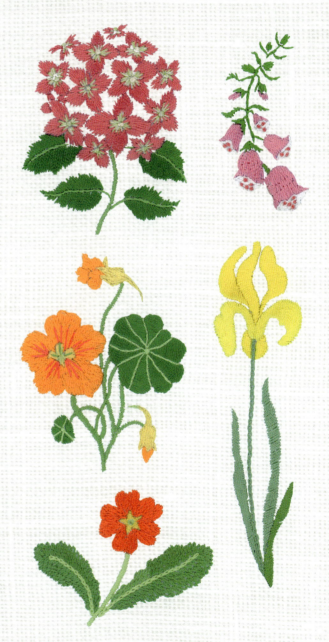

Introduction	4
The meaning of flowers	6
Tools and materials	8
Techniques	12
Stitches	16
Spring is in the air	22
Lily of the valley egg cosies	27
Primrose tray cloth	30
Kitchen garden	34
Marigold cake band	38
Nasturtium napkin	42
Bright and beautiful	44
Lily framed picture	48
Violets needle case	52
Cottage garden	56
Sweet William baby dress	60
Pansy hoop	64
Scents of summer	68
Honeysuckle apron	73
Bouquet cushion	76

Exotic blooms	80
Mexican blouse	86
Orchid drawstring bag	90
Sunny meadow	94
Poppy picnic cloth	97
Buttercups and daisies cutlery wrap	100
Herbaceous border	102
Lavender sachet	107
Aster towel border	110
Woodland walk	112
Bluebell bookmark	116
Blackberry book bag	120
Winter wonders	124
Snowdrop greetings card	128
Camelia napkin	132
Index	134
Acknowledgements	134

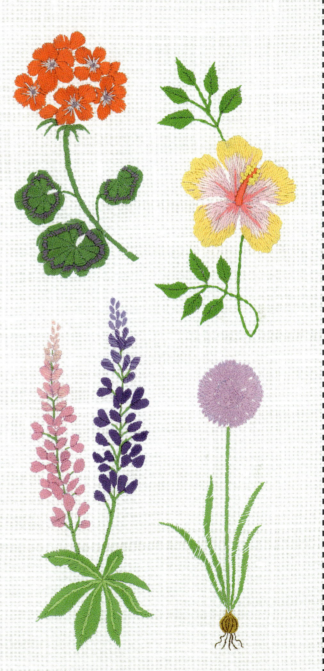

INTRODUCTION

Flowers are arguably the most popular subject for embroidery, and this book offers a wealth of new, original designs. And because this is intended to be an embroidery book for all creative stitchers, there are also comprehensive guides to materials, tools and techniques to help you to achieve rewarding results.

There are more than 100 flower designs here: popular flowers, both wild and cultivated, from daffodils and primroses, through favourite garden flowers such as pansies, roses, fuchsias and lilies, to exotic orchids, passion flowers, nicotiana and hibiscus.

The book is divided into ten sections, grouping flowers according to the places they tend to grow; this might be their natural environment, or where we choose to plant them, or the seasons when they thrive. Gardeners of every kind – even city-dwellers with only a balcony or a windowsill – will find some of their favourite flowers blooming on these pages.

The motifs are provided as line drawings for you to trace from the page or photocopy, reducing or enlarging them as you please. There is a stitched example of each motif to inspire you and to show how various stitches can be used and combined.

To help you decide how to use the motifs, there is a selection of 20 projects: each one is described in words and pictures to simplify the processes involved. Display your handiwork in a hoop or picture frame; decorate your clothes and table linen with pretty blooms; or make a needle case or a book cover for yourself or to give as a gift.

Hand embroidery is a timeless craft that requires a good eye, a steady hand and very little in the way of equipment and materials: a needle, some fabric and thread. More than this, it is very absorbing and also very therapeutic. Use these simple traditional skills to stitch some beautiful flower motifs and utilize the choice of thread colours in your work box to make them really come to life.

If you are new to embroidery, start with something straightforward: a simple, small motif such as the iris (page 45) or the ivy border (page 125), using outline stitches such as backstitch, split stitch, blanket stitch and chain stitch. From there you can progress to filling stitches and slightly larger motifs: the forget-me-not spray (page 25), chive (page 35), or chrysanthemum (page 103). As your stitching gets neater and more even, move to larger motifs and maybe some colour shading: the marigolds (page 34) or freesia (page 72).

When you are really confident, try some of the more elaborate designs that will take a little longer to complete and show your embroidery skills to best advantage: the passion flower (pages 82 and 83) or the exotic frame (page 81). If you really want to challenge yourself, select a design that can be repeated to create a border: the exotic border (page 85) or flowering vine (page 80) are designed especially for this. Or choose multiple motifs and combine them in a large floral arrangement, then frame the results.

I love coming up with new designs and I can't decide which I enjoy more: drawing the motifs or stitching them. I love all aspects of the process. I hope that I have managed to include plants that will appeal to a wide audience. I have been inspired by – and therefore included – my own favourites, which are pelargoniums and pansies (long-lasting and reliable), honeysuckle and sweet peas (dainty and fragrant) and nasturtiums (colourful and easy to grow from seed). The theme of flowers really appeals to me and I hope you will enjoy stitching the motifs as much as I did and will continue to do.

SUSIE JOHNS

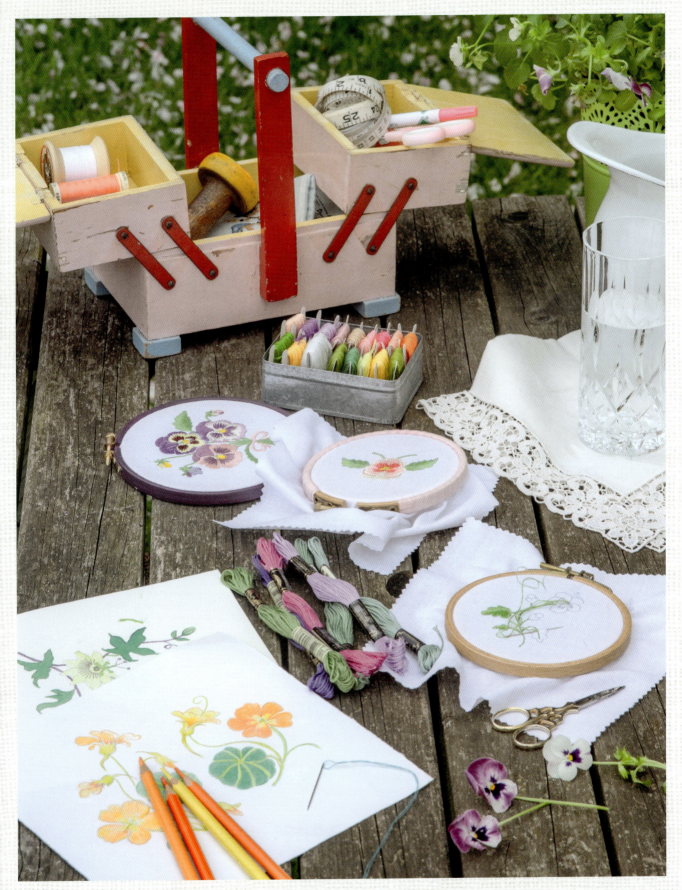

THE MEANING OF FLOWERS

Special meanings have been attributed to flowers in many cultures. This symbolism was particularly popular in Victorian Britain, when flowers would be used to deliver messages, secret or otherwise. Even today, a whole range of sentiments can be expressed when giving flowers as a gift for birthdays, Valentine's Day, the birth of a new baby or other occasions. Definitions may have altered over time, and in some cases can vary according to the colour of the flower, but the list below outlines the popular meanings of most of the flowers in this book, dating from the Victorian era.

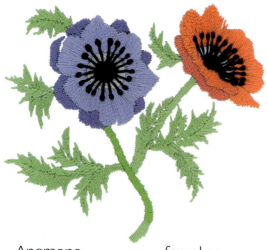

Anemone	forsaken
Apple blossom	preference
Aster	daintiness; a symbol of love
Bluebell	humilty; constancy; courage
Borage	bluntness; directness
Buttercup	playfulness; friendship
Camelia, pink	longing for you
Carnation	fascination; mother's love
Cherry blossom	mortality; life and death
Chives	usefulness
Chrysanthemum	fidelity; joy; optimism
Clover	think of me
Crocus	cheerfulness; youthful gladness
Daffodil	unequalled love; regard
Dasiy	innocence; loyal love
Fennel	flattery
Fern	fascination; secret bonds of love
Forget-me-not	do not forget me
Foxglove	insincerity
Freesia	trust and friendship
Geranium	folly, stupidity
Hibiscus	delicate beauty

Holly	domestic happiness	Mistletoe	fertility; vitality
Honeysuckle	bonds of love	Morning glory	affection
Hyacinth	sport; play	Nasturtium	patriotism; victory in battle
Hydrangea	frigidity; heartlessness	Orchid	luxury; beauty; strength
Iris	faith; trust; wisdom; hope	Pansy	thoughts
Ivy	affection; friendship; fidelity	Passion flower	suffering
Larkspur	open heart; fickleness	Poppy	consolation
Lavender	distrust	Primrose	early youth
Lilac	purity; innocence	Rose	happiness
Lily	beauty	Snowdrop	new beginnings
Lily of the valley	sweetness; humility	Sunflower, dwarf	adoration
Lupin	strength and protection	Sunflower, tall	haughtiness
		Sweetpea	blissful pleasures; departures; thank you for a lovely time
		Sweet William	gallantry
Marigold	grief; jealousy	Tulip	fame
Michaelmas daisy	afterthought	Violet	watchfulness; modesty; faithfulness

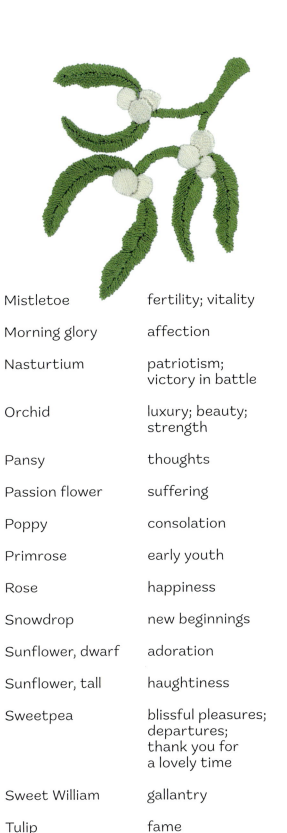

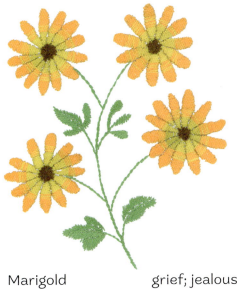

TOOLS AND MATERIALS

Compared to many other crafts, embroidery requires little in the way of equipment: to make a start, you need only a needle, some fabric and a few embroidery threads. In addition to these basics, an embroidery hoop makes working much easier and tends to produce better results, while a good pair of sharp embroidery scissors is essential.

EMBROIDERY THREADS

Thread is a vital component: after all, it is the material from which the stitches are formed. Try to use the best threads you can afford as cheaper versions can be inferior in quality, with a tendency to break, and the dyes might run when the embroidered fabric is washed.

Six-stranded cotton embroidery thread, otherwise known as floss, has been used throughout this book and is very versatile. Loosely wound in a skein, individual threads can be separated and then combined, so you can use any number of strands. The number of strands should suit the scale of the design and the weight of the fabric. All of the projects in this book use two strands.

Other embroidery threads, such as satin floss and perle cotton, are available, but have not been used in this book.

You will need sewing thread for stitching fabric pieces together. Cotton thread is a good choice for cotton and linen fabrics, though an all-purpose thread, made from polyester, can also be used for most lightweight and medium-weight fabrics.

NEEDLES

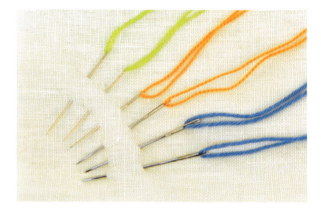

It is essential to use the right needle for the task. You need to choose one that is suitable for the thickness of the fabric and the thread.

Crewel needles are specially designed for embroidery. They are medium-length with a sharp point and a long eye to accommodate several thicknesses of thread. The longer eye makes them easier to thread. They are available in sizes 1 to 12: the smaller the number, the finer the needle. Try to use the smallest possible needle, as it will be easier to push through the fabric. Your choice will be influenced by the number of thread strands you are using. As a guideline, a size 4 or 5 will accommodate two strands of stranded cotton; for three strands you will need a size 6 or 7.

CHANGING NEEDLES

After a lot of use, a needle will become blunt; if you are finding it difficult to push a needle through the fabric, or if the fabric snags when you push the needle through, then discard it and use a new one.

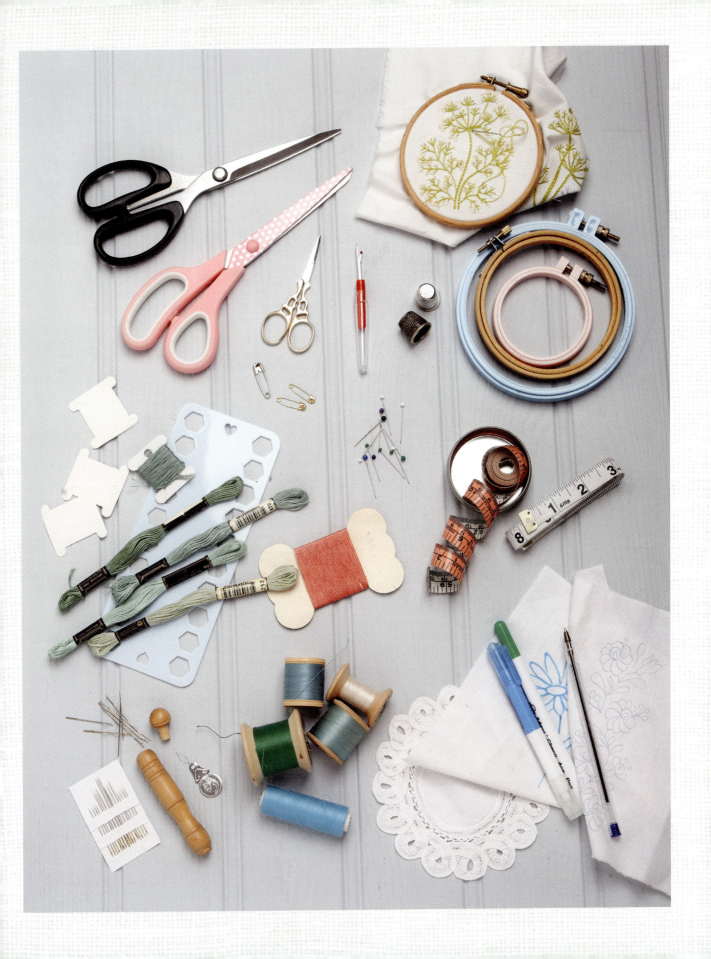

FABRIC

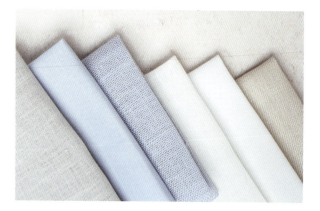

You will need a plain-weave fabric. Cotton or linen with a smooth, tightly woven texture are the best choices. Both cotton, which is relatively inexpensive, and linen, which costs a little more, are natural fabrics: a good reason for choosing these is that the needle glides in and out more easily than it does with synthetics. To prove this for yourself, try out some sample stitches on a piece of pure cotton or linen and then try some on a poly-cotton or other synthetic fabric.

Many of the samples and projects in this book have been stitched on to old fabrics. You can, of course, buy new fabric, cut from a roll or pre-cut as fat quarters or remnants. If you choose new fabrics, it is a good idea to wash them first, as they might shrink, and it is better if that happens before you embroider them. Old fabrics, sourced from junk shops, flea markets, antique fairs or Granny's attic, are likely to have been washed already – probably many times – and therefore are much less likely to shrink. Vintage and antique fabrics may also show signs of wear in the form of rips, stains and other flaws, so choose the cleanest examples you can find and, if necessary, position your embroidery motif carefully so it covers up any marks.

> ### PREPARING FABRIC
> When using natural fabrics, if they are not pre-shrunk, they should be washed and ironed before you begin stitching. This applies even if the finished item is something like a framed picture, which will not be laundered, as washing the fabric will make it softer and easier to work with, allowing the needle to glide through easily.

SCISSORS

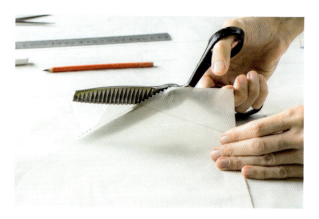

Embroidery scissors are small with sharp, pointed blades, essential for snipping threads and cutting away small areas of fabric. For cutting out fabric pieces, you will need a larger pair of scissors that should be reserved for cutting only fabric – never paper – and a pair of all-purpose scissors for cutting paper and card when making templates.

Scissors should be kept sharp: blunt scissors will make cutting fabric difficult. A quick and easy way to do this is to use sandpaper. Fold a sheet of fine (220–240 grit) sandpaper in half, with the rough side facing outwards. Use the scissors to cut the sandpaper into long strips, making sure you open out the scissors fully at the beginning of each cut and use the whole blade for cutting. Having cut about 12-15 strips, test the scissors by cutting a piece of fabric.

Pinking shears are useful for cutting fabrics that are liable to fray.

EMBROIDERY HOOPS

These consist of two wooden or plastic rings, the larger of which has a screw that can be tightened or loosened to accommodate fabrics of different weights. Hoops hold the fabric taut, which is important when working stitches that might otherwise cause the fabric to pucker and distort.

As a general rule, stretching fabric in an embroidery hoop makes it easier to control the embroidery stitches and achieve an even tension. You can adjust each stitch as it is formed, making sure that it sits neatly on the surface of the fabric. If you work without a hoop, there can be a tendency for the thread to be pulled too tightly and the fabric to become puckered. The hoop can be moved around your piece of work, so there is no need to buy a hoop that is larger than your project.

MARKERS

With most hand embroidery, you will need to mark guidelines on the fabric, so you know where to place the stitches.

If the stitches will cover these lines completely – as in satin stitch, for example – the lines can be drawn with some kind of permanent marker. For drawing permanent lines, an old-fashioned biro (not a gel pen or rollerball) or an ordinary graphite pencil can be used. Before using one on a project, however, do a test to make sure the marks are permanent. Draw some marks on a scrap of fabric using your pen or pencil, then dampen the fabric and rub the marks with your fingertips to make sure they do not smudge or run.

If, however, the stitches will be more open, and the design lines will show through, then the lines need to be drawn with a marker that will fade or that can be removed. For making temporary marks on fabric, there are various pens and pencils available to buy. The ones that fade away by themselves are most useful for small areas of embroidery that are to be finished quite quickly, as you don't want the marks to fade before you have had a chance to finish the stitching.

Lines drawn with water-erasable markers will last longer and can be removed with water once the embroidery is complete. For small areas, to remove the pen marks, try rubbing them with a cotton bud dampened with cold water; for larger areas, you may need to immerse the fabric in water in order to remove the marks. Once again, it is wise to practise on a scrap of fabric first.

Tailors' chalk pencils, some of which have a brush on the end for erasing chalk marks, are useful for marking designs on dark fabrics.

Some pens and pencils are suitable for making marks directly on the fabric, and some are used to transfer marks from paper to fabric using a heat source such as an iron. Be aware that transfer pens and pencils leave permanent marks on fabric.

OTHER USEFUL ITEMS

Dressmakers' pins can be useful for holding layers of fabric together when making embroidered projects. Buy good-quality steel pins that will not rust or become blunt; keep them in a lidded box.

A tape measure is useful for measuring fabric, while a ruler is invaluable for drawing straight lines accurately.

A thimble is a useful accessory for some embroiderers, whereas others find it unnecessary or cumbersome.

You may wish to use a sewing machine for joining fabrics when making some of the projects in this book, but most can be hand sewn.

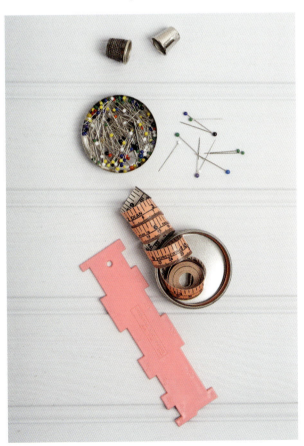

PRESSING EMBROIDERY

A piece of fabric that has been held in an embroidery hoop will become creased, so a steam iron is invaluable. But take care: when pressing an embroidered piece, you should avoid squashing and flattening the stitches. It is advisable to place something soft, such as a folded towel, underneath the embroidered fabric, to provide a cushioned bed for the embroidery. Place the embroidery right side down and cover it with a pressing cloth before ironing carefully.

TECHNIQUES

Once you have a suitable piece of fabric and you have selected a palette of coloured threads, you are ready to start stitching. The key to a good result is to keep the stitches neat and maintain an even tension. Here are some techniques and useful tips to help you do this, from marking out your design on the fabric to caring for your completed work.

PREPARING TO STITCH

When working embroidery stitches on a plain weave fabric, it is important to match the weight of the thread and the thickness of the needle to the fabric. If the needle is too thick, it is likely to create holes in the fabric; if the thread is too thick, it will not sit neatly on the surface of the fabric.

MARKING DESIGNS

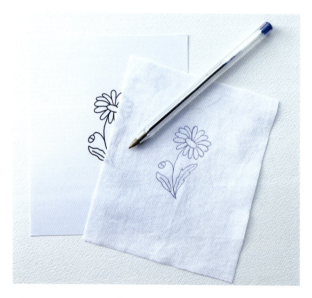

Direct tracing is the easiest, quickest and most straightforward way of drawing a design onto fabric. A lightweight fabric may be thin enough to lay on top of a design in order to trace the lines directly. With fabrics that are less translucent, you will find a light box useful, to make the lines of the design visible through the fabric. Modern LED light boxes are small, portable and slimline (the older designs were often heavy and cumbersome). You can find examples that are about the size of an A4 or A3 sketchbook, with USB connections.

If you don't have a light box, you can improvise by taping the printed design to a window: tape the fabric on top and you should be able to see the design and trace it on to the fabric. With any direct tracing method, you will usually first need to trace or photocopy the design from the book on to plain paper.

An alternative to tracing is to make a heat transfer. For this, you will need a heat transfer pen or pencil – available from embroidery suppliers – and thin white paper, such as layout or 'bank' paper (but not tracing paper, which tends to cockle under the heat of the iron). Lay the paper over the design and trace it, using the transfer pen or pencil. Then lay your fabric on an ironing board, place the tracing face down on the fabric and carefully press with a hot iron, taking care that the paper's position doesn't shift or the transferred lines will be blurred. After the allotted time – check the guidelines for your particular pen or pencil – you can lift off the paper to reveal the design on the fabric. One thing to bear in mind here: when using this method, your design will be reversed, so reverse your chosen motif or lettering when making your initial drawing.

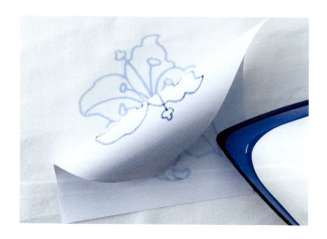

ENLARGING AND REDUCING MOTIFS

If you find a motif you would like to embroider but want it to be larger or smaller, you can easily change the size by scanning the motif on to a computer and altering the scale, or by using the reducing and enlarging facility on a photocopier. To calculate exactly how to achieve a particular size, see the formula below to calculate the percentage.

TO ENLARGE A MOTIF

Measure the motif you wish to use and decide what size you want it to be. Divide the finished size by the original size, then multiply by 100 to achieve the percentage.

For example:
the original motif is 2in (5cm) high
the desired size is 5in (12.5cm) high
5 ÷ 2 = 2.5 × 100 = 250
You will need to photocopy the motif at 250%.

TO REDUCE A MOTIF

This is done using the same formula as for enlarging, but the calculated percentage will be less than 100.

For example:
the original motif is 5in (12.5cm) high
the desired size is 2in (5cm) high
2 ÷ 5 = 0.4 × 100 = 40
You will need to photocopy the motif at 40%.

PREPARING THE FABRIC

Your fabric should be smooth and wrinkle-free, so press it with a hot iron before stitching to remove creases.

Choose an embroidery hoop smaller than your piece of fabric. You will discover with practice what size of hoop feels most comfortable and practical for you. You may wish to see the whole design within the hoop or you may prefer to use a smaller hoop and move it to different areas of the design as you work.

So that the fabric is held firmly between the rings of the hoop, it is a good idea to bind the inner ring using cotton tape, bias binding or bias-cut strips of fabric. Place your fabric on top of the plain ring of the embroidery hoop, then place the other part of the hoop – the one with the opening and the screw fitting – on top, pressing it down until the two parts of the ring align. You may have to loosen the screw in order for it to fit. Once in place, you will need to tighten the screw so that the fabric is held firmly in place.

Tug gently on the edges of the fabric so that it is taut – but take care not to distort the fabric, as the grain should be kept straight.

The cut edges of the fabric are liable to fray, so you may wish to hem them or simply trim them with pinking shears.

BINDING A HOOP

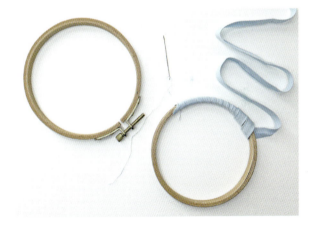

Wrap one end of the fabric strip or tape around the hoop close to the base of the brass screw on one side and hold it in place with a few stitches. Wind the strip around in a diagonal fashion, overlapping the long edges and stitching them in place at intervals as you do so, until you reach the starting point, then attach the end with a few more stitches, close to the other part of the screw.

PREPARING THE THREAD

Six-stranded embroidery thread is sold in skeins, held in place with two paper bands. Do not remove these bands but hold the skein in one hand and pull on the loose end at the bottom of the skein to draw out a length of thread. Separate this length into the number of strands you wish to use – typically, one, two or three strands. Separate the strands by pulling them out individually. If you try to pull out more than one at a time, they will most likely twist, then tangle and knot together.

If your skein does become tangled, you may wish to wind the thread onto a bobbin. These are sold precisely for this purpose and are available made from card or plastic. You can keep a record of the thread shade number by writing it on the bobbin, and bobbins can be stored in a box with a lid to keep them organised and dust-free. You can also buy flat pieces of plastic with holes along the side, for organising long lengths of thread or for attaching short pieces of thread to act as a colour key. You could also make your own by punching holes along the edge of a piece of sturdy cardboard.

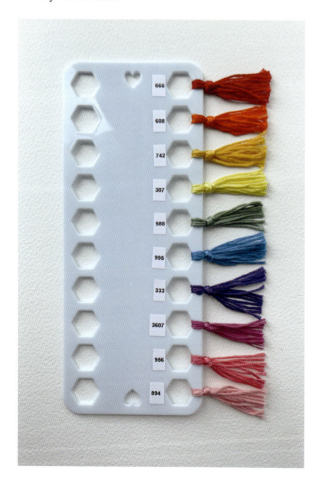

THREADING A NEEDLE

Sometimes it can be difficult to pass the cut ends of embroidery thread through the eye of a needle, especially if you are using more than one strand. One solution is to fold the ends of the threads over the needle, pull tight, then pass the fold through the eye, instead of the cut ends themselves. Another solution is to use a needle threader.

USING A NEEDLE THREADER

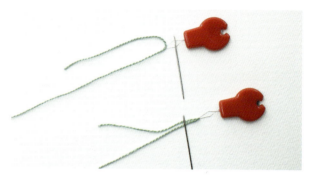

Store-bought needle threader

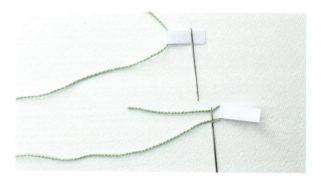

Improvised needle threader

Threading a needle can sometimes be frustrating, so it is useful to keep a needle threader in your workbox. A needle threader has a wire loop that you push through the eye of the needle; pass the end of the thread or threads through the loop, then withdraw the wire loop from the needle, thereby pulling the thread through the eye. If you don't have a needle threader, you can improvise with a short length of very thin wire.

Another good alternative is to use a small strip of thin paper folded in half. Cut a piece of paper about 2in (5cm) long and narrower than the eye of the needle. Fold the strip in half across its width. Place the end of the thread inside the fold and push the fold through the eye of the needle.

STITCHING TECHNIQUES

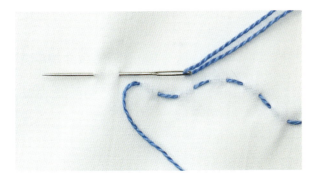

Sewing

Stabbing

There are two basic ways to insert the needle into the fabric when forming an embroidery stitch: sewing and stabbing. The method you choose is a matter of personal preference.

The sewing technique entails taking the needle in and out of the fabric in a single motion. As the needle scoops up a little of the fabric when using this method, it is usually best done without an embroidery hoop.

The stabbing technique means taking the needle through the fabric from front to back, then from back to front, in two separate journeys.

When you are learning a new embroidery stitch, it can be a good idea to try working it using each of the two methods to see which of them works best for you. The likely outcome of this type of experiment is that you will find that some stitches work better for you using the sewing technique – such as running stitch and backstitch – while others work better with the stabbing technique. You may also find that one method works best when the direction of stitching is from right to left, while the other method works best going from left to right; you may even find yourself alternating the two methods.

FASTENING THREAD TO FABRIC

Some embroiderers start stitching by knotting the end of their thread while others consider this to be bad practice. There are definitely disadvantages in knotting the end of the thread: it can cause a lump; it can show through on the front of the work or even pull through; and it might actually come undone, causing your stitches to unravel.

There are several alternative ways to attach a new thread before starting to stitch, perhaps the most straightforward being the waste knot. This entails knotting the end of the thread then inserting the needle down through the right side of the fabric, a short distance from the design area, leaving the knot sitting on the surface of the fabric. As you start to stitch, the tail of thread is covered by the stitches on the wrong side, locking the thread in place. Once the thread is secure, you can trim off the knot and any excess thread. Once you have stitched an area of the fabric, new lengths of thread can be secured under the existing stitches by passing the needle back and forth under these threads two or more times.

To fasten off a length of thread, when you have finished stitching, take the needle to the wrong side of the work and pass it under the back of the stitches. Make sure it is secure, with no risk of unravelling, then trim off the excess thread. Make sure you stop stitching before the thread becomes too short; you need to have enough left to take it through to the back and pass it under a sufficient number of stitches.

AFTERCARE

Hopefully, you will be proud enough of your finished work to wish to frame it or perhaps to make it into a cushion or other item that will be on show. The fabric and threads may fade over time, but in the meantime you will have the opportunity to enjoy looking at your handiwork and allowing others to do so too.

If, on the other hand, you want to store a project then, traditionally, the advice has been to store finished embroidery pieces flat and in a dark place so that the thread colours don't fade. Where practical, you should lay your pieces unfolded in a box with layers of white acid-free tissue paper. Larger pieces can be rolled around a cardboard tube covered with tissue, right side out, then overwrapped with more tissue.

STITCHES

Below we cover the different embroidery stitches that you will need to complete the designs showcased in this book. Throughout the book, each motif is accompanied by one stitched example, using these stitches – but it is by no means the only way to interpret the design. Use your own stitch combinations and thread colours to personalize your embroidery.

RUNNING STITCH

Starting on the right, bring the needle up at the beginning of the line to be worked. Working from right to left, make the first stitch by inserting the needle back down into the fabric a stitch length from the beginning and up again a little way along the line. Repeat this action all along the stitch line. To make an even line of stitches, the stitches and the gaps in between should be a similar length. Running stitch is usually worked from right to left but you can work left to right if you find this easier or if you are left-handed.

BACKSTITCH

Backstitches should be neat and regular; they are useful for outlining and for fine stems. Work this stitch from right to left: bring the needle out a short distance from the beginning of the line to be covered, insert it again at the beginning of the line – thus taking a step back – and bring it out an equal distance beyond the point where it first started. Pull the needle through and you are ready for the next stitch.

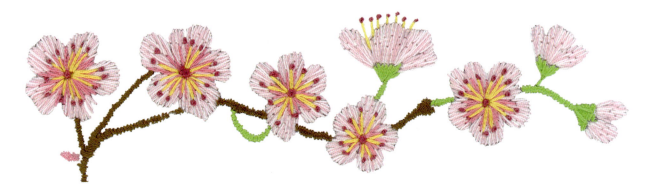

BLANKET STITCH

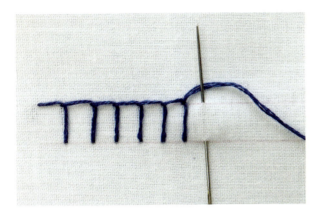

Bring the needle up through the fabric on the line. Insert it a little way to the right and below the line, then back up through the upper line immediately above, making sure that the loop of thread is behind the needle; pull it through to make the first stitch, then, working from left to right, repeat the process, taking the needle down through the fabric below the line and up on the line, creating a small loop each time and spacing the stitches evenly.

BULLION STITCH

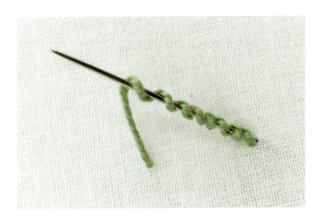

This forms a short coil of thread like a little caterpillar, and is useful for flower centres and anthers. Bring the needle up through the fabric but do not pull it through. Twist the thread around the tip of the needle six or seven times, place your thumb on the twists, then pull the needle through both the fabric and the thread. Then, allowing the coil of thread to lie flat on the fabric in the chosen position, reinsert the needle a short distance from where it emerged.

BUTTONHOLE STITCH

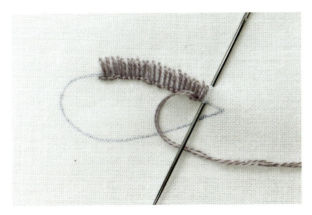

The difference between blanket stitch and buttonhole is in the spacing of the stitches. With buttonhole, the stitches are close together, with no gaps in between, while with blanket stitch – sometimes called open buttonhole – there are spaces between the stitches, and these are usually evenly spaced, though the spaces can be varied depending on the effect you wish to achieve.

FISHBONE STITCH

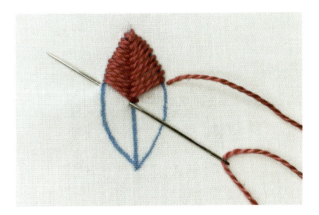

This is a popular stitch for filling simple leaf shapes. Draw a line down the centre of your leaf shape. Bring the needle out on the right-hand side of the leaf, close to the tip, then insert it just to the left of the centre line, then bring it out on the top left of the leaf and in again below the previous stitch and to the right of the centre line. Repeat the process, moving down the shape until it is completely filled.

FLY STITCH

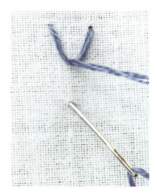
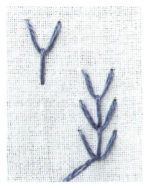

This is a kind of open detached chain stitch, sometimes called y-stitch because it resembles a letter 'Y'. Bring the needle up through the fabric, insert it a little distance to one side and pull through, leaving a small loop. Then bring the needle back out through the fabric a short distance below, coming through the loop and over the thread to form the 'stalk' of the stitch.

CHAIN STITCH

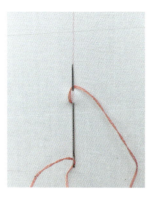
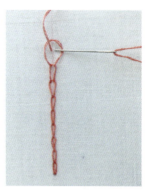

In chain stitch, linked loops create a line that resembles a chain. Bring the needle up through the fabric at the base of the stitch and back down in the same spot, pulling it through to leave a tiny loop of thread. Bring the needle up through the loop – the distance will determine the length of the stitch. Take the needle over the thread and back through the fabric. It can be used as single stitches – known as a detached chain or 'lazy daisy' because it resembles a flower petal – or repeat the looping process to make a line of chain stitches.

FRENCH KNOT

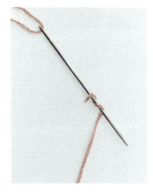

This forms a neat knot on the surface of the fabric, like a small seed, perfect for flower centres. Bring the needle up through the fabric at the point you wish to place the knot and twist the tip of the needle one, two or three times around the thread where it emerges from the fabric. With the twists held tightly, insert the tip of the needle close to where it first emerged and pull through, holding the twists and allowing a small knot to form on the surface of the fabric. The number of twists will determine the size of the knot: for a larger knot, do not add more twists but use a thicker thread.

WOVEN WHEEL

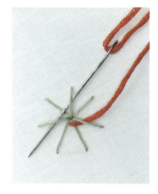
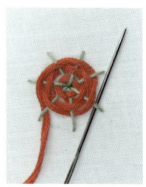

This stitch produces a neat textured circle and is useful for flower centres. This stitch is worked by weaving thread in and out of a foundation of straight stitches arranged like the spokes of a wheel. Make an odd number of straight stitches – in this case, seven – of the same length, radiating out from a central point. Thread a blunt needle with the same or a contrasting thread and bring it up through the fabric, close to the centre. Working anti-clockwise, take the needle over the first 'spoke' and under the next. Continue in the same direction, taking the needle alternately over and under each straight stitch.

LONG AND SHORT STITCH

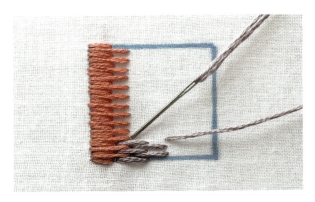

This is an excellent alternative to satin stitch when you need to fill a larger shape, and it allows for subtle colour changes to create shaded effects. Work the first row with alternating long and short stitches, with no gaps between stitches; for subsequent rows, work stitches of equal length. As you make each stitch, insert the needle into the same place as the end of the corresponding stitch on the previous row.

OVERCAST STITCH

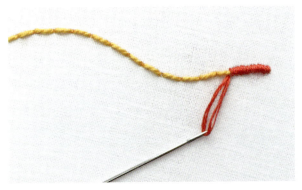

Overcast stitch creates a smooth, raised line, like a fine cord, when worked over a line of backstitch or split stitch, perfect for fine flower stems. Start by working backstitch along the line. Bring the needle up close to the line, then back down through the fabric on the opposite side. Continue like this, working over the foundation outline, to create a neat, cord-like stitch.

SATIN STITCH

 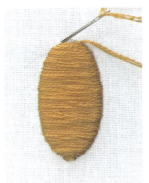

This popular filling stitch appears to be quite easy to work, but a lot of skill is required to produce a neat, even finish. You will need to make the stitches lie closely together while preserving a neat edge to the shape being filled. Bring the needle up through the fabric on one side of the drawn outline and take it down on the opposite side of the shape, then under the fabric and out again adjacent to the starting point. Stitches do not have to be parallel but can fan out to fill a petal or leaf shape.

PADDED SATIN STITCH

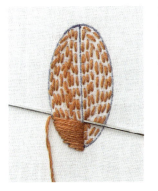 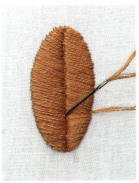

This version of satin stitch ensures good coverage when used to cover small areas, with no fabric show-through and a lightly padded effect. Fill the shape with a foundation of running stitch, with the stitches close together to ensure good coverage, then use satin stitch on top to fill the shape, making sure that the stitches lie close together, to completely cover the running stitches. For extra padding, work another layer of satin stitch on top of the first, with the stitches lying in a different direction.

SPLIT STITCH

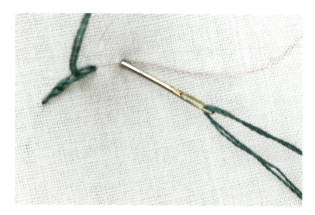

This is a useful outlining stitch and is suitable for thin stems. The method, working each stitch backwards from the spot where the needle last entered, is similar to stem stitch or backstitch. However, as the needle emerges up through the fabric it splits the stitch just worked. The result looks a bit like a fine chain.

STEM STITCH

This is another useful stitch for outlining and – as the name suggests – for stems. Bring out the needle at the end of the line to be covered, then insert it a little way to the right, bringing it out again back to the left, about halfway above the stitch just formed. Repeat this process moving from left to right along the line.

SPLIT STITCH FILLING

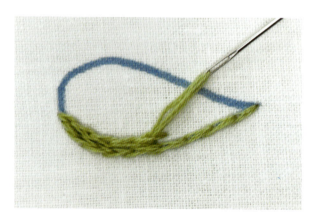

You can also use split stitch as a filling, simply working rows close to each other to cover the fabric to create a close-woven appearance.

STRAIGHT STITCH

This consists of a single isolated stitch of any length and is useful for small details such as stamens or for the woven wheel stitch (page 18).

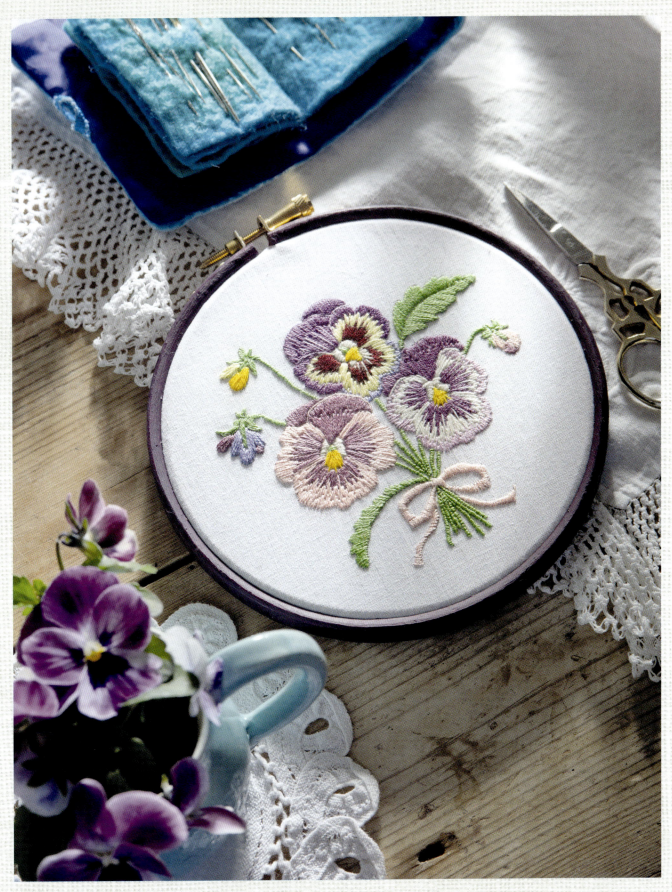

SPRING IS IN THE AIR

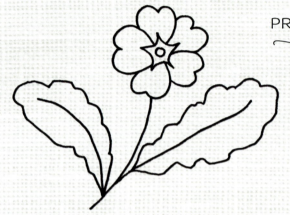
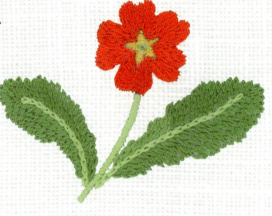

PRIMULA

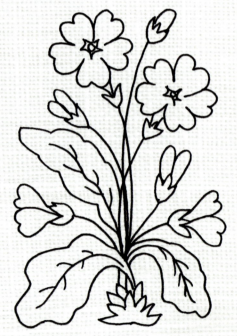
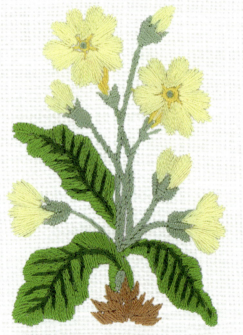

PRIMROSE

MOTIFS

TRAY CLOTH MOTIF

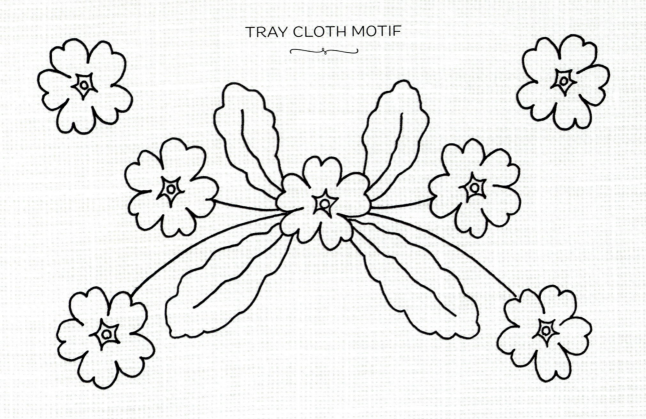

PRIMULA RING

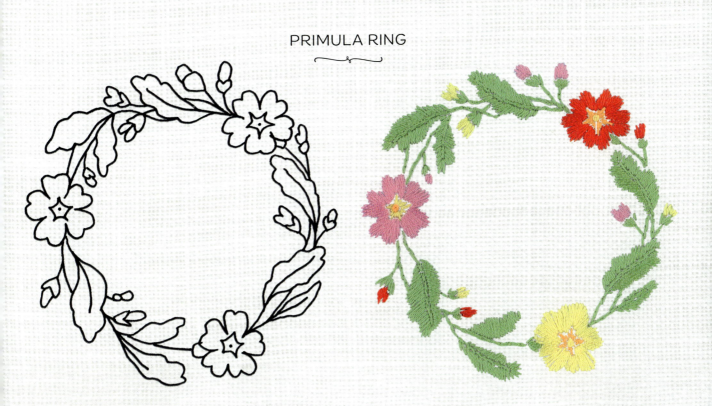

SPRING IS IN THE AIR

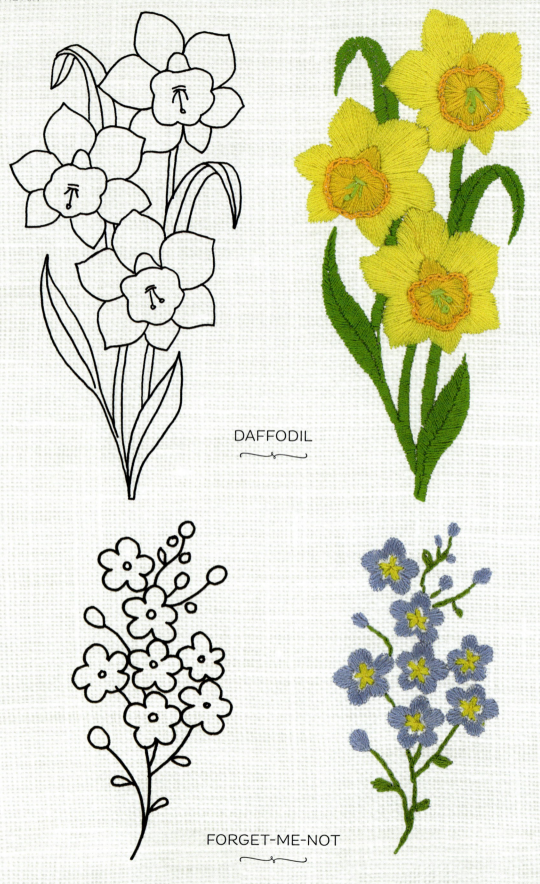

DAFFODIL

FORGET-ME-NOT

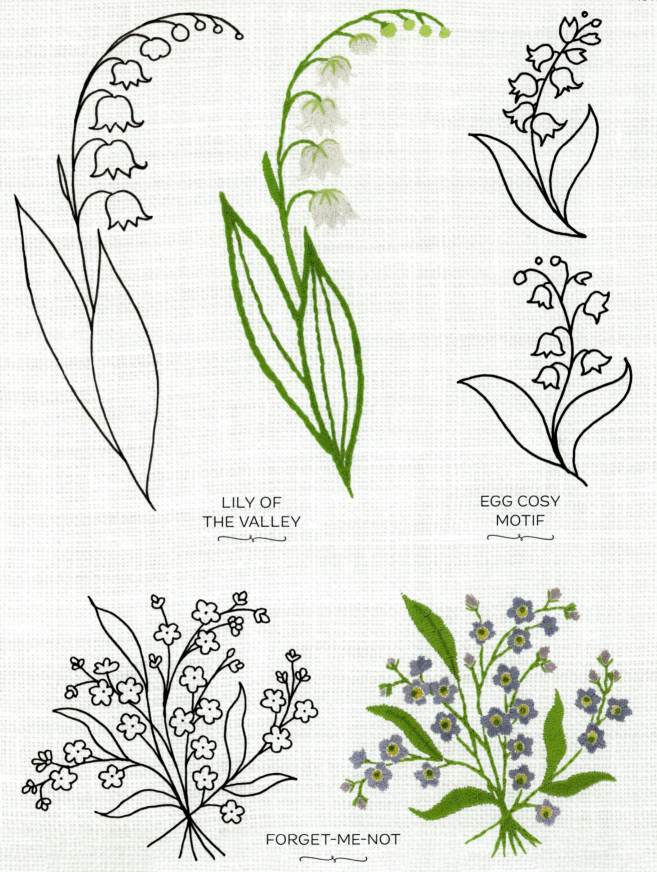

SPRING IS IN THE AIR

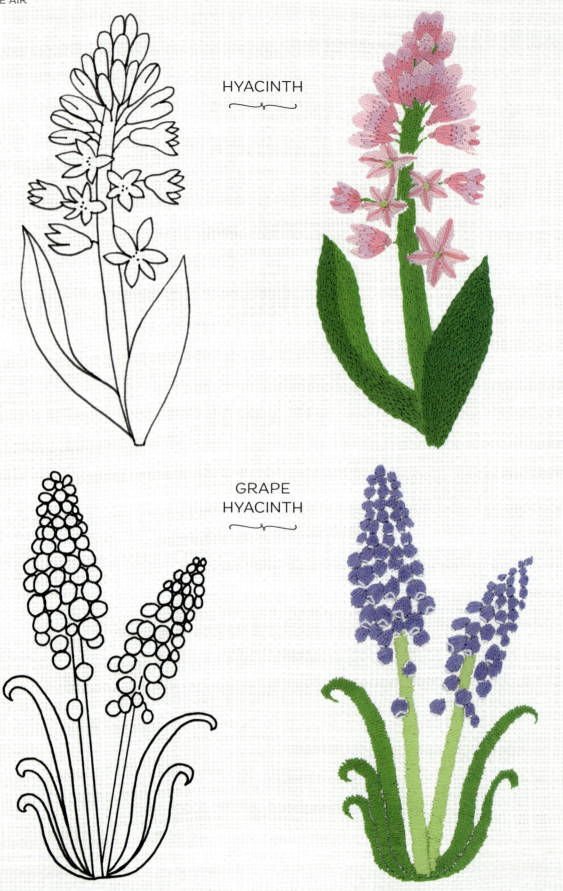

HYACINTH

GRAPE HYACINTH

LILY OF THE VALLEY EGG COSIES

Keep your boiled eggs nice and warm with these pretty egg cosies featuring dainty lilies of the valley. These pretty little flowers are one of the joys of spring, with their sweetly scented bell-shaped flowers, and are certain to cheer up the breakfast table on a dull winter's day

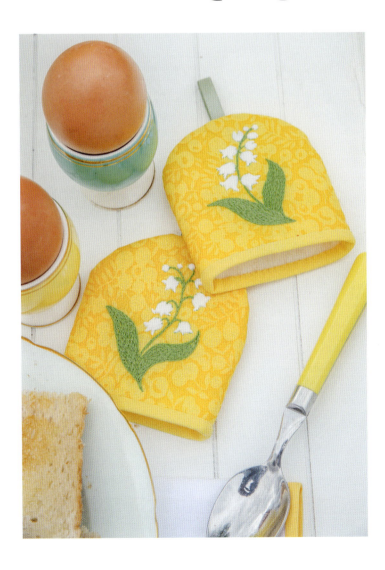

YOU WILL NEED

- Cotton, plain or printed, approximately 10in (25.5cm) square
- Lightweight fusible wadding, approximately 8 × 7in (20 × 18cm)
- DMC six-stranded thread:
 moss green 988
 white B5200
- Embroidery hoop, 4¾in (12cm) diameter
- Crewel (embroidery) needle
- Ballpoint pen or erasable marker
- Sewing thread to match fabric
- Narrow ribbon, 6¼in (16cm) long
- Bias binding, 14in (36cm) × ⅝in (15mm) wide

STITCHES USED

- satin stitch (p. 19)
- split stitch (p. 20)
- split stitch filling (p. 20)

TIPS

- Choose a medium-weight craft cotton, plain or printed, for the main fabric.
- When drawing the design on the fabric, bear in mind that the lines should be covered by the stitches but may still be visible through the white thread, so you may prefer to use an erasable marker.

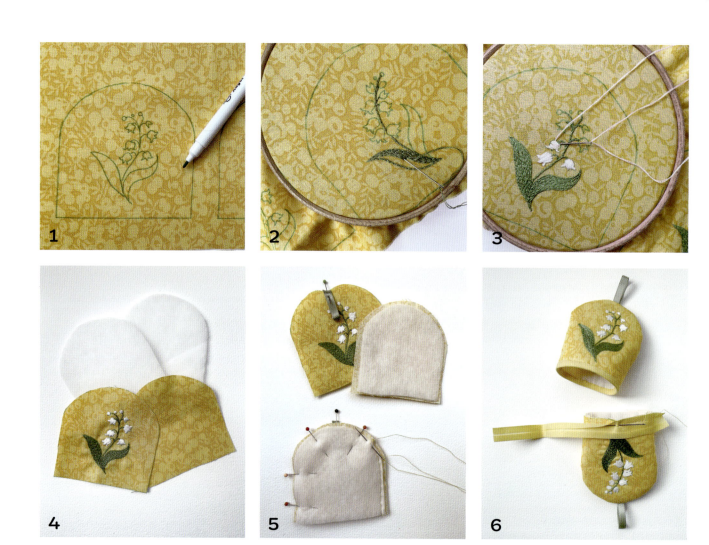

EMBROIDERING THE MOTIF

Use two strands of thread throughout

1. Draw the egg cosy outlines on one half of the main fabric; the other half will be used for the backs of the cosies. Trace or transfer the egg cosy motif (page 25), positioning each one centrally, with the base of the stems ⅜in (1cm) from the bottom edge.

2. Place the fabric in an embroidery hoop; the suggested size will fit the whole design. Using moss green 988, embroider the stems in split stitch and the leaves in split stitch filling.

3. Using white B5200, fill in the flowers in padded satin stitch. Work a series of stitches across the shapes first, then go over them, creating a second layer with the stitches lying vertically.

Remove the fabric from the hoop and erase the lines, if you have used an erasable marker. Press the work on the reverse, following the pressing guidelines on page 11.

MAKING THE COSIES

4. For each cosy, cut out two pieces of fusible wadding slightly smaller all round. Apply one to each of the fabric pieces, using a hot iron and following the manufacturer's guidelines.

5. Cut the ribbon into two equal lengths, fold each one in half and pin to the top of the embroidered piece, with cut edges lined up with the edge of the fabric. Place two egg cosy pieces, one back and one front, right sides together and pin, then stitch ¼in (6mm) from the edge, leaving the bottom edge unstitched.

6. Turn right sides out. Cut the bias binding into two equal lengths and use these to bind the raw edges at the base of each cosy.

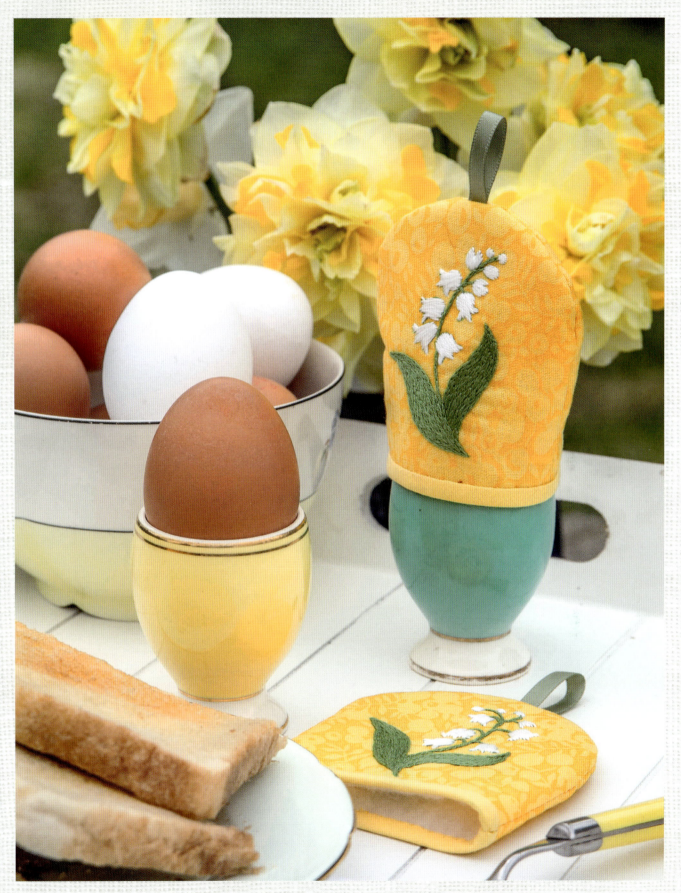

PRIMROSE TRAY CLOTH

Primroses come in a range of bright and pastel colours, not just the pale yellow wild primroses – *Primula vulgaris* – that are one of the first signs that spring has arrived. Here they adorn a tray cloth just right for an early morning cup of tea – or even breakfast in bed. Use the colours shown here or choose your favourites.

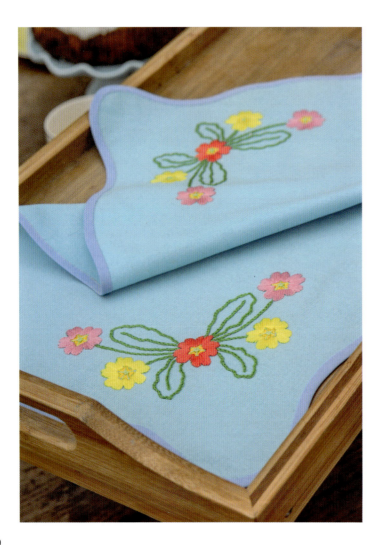

YOU WILL NEED

- Cotton fabric, plain or printed, approximately 22½ × 15in (57 × 38cm)
- DMC six-stranded thread:
 tea green 16
 sunshine yellow 444
 emerald green 702
 rose red 891
 deep rose 3806
 primrose 307
- Embroidery hoop, 7in (18cm) diameter
- Crewel (embroidery) needle
- Ballpoint pen or erasable marker
- Bias binding, 50in (127cm) × ⅝in (1.5cm) wide
- Sewing thread to match binding

STITCHES USED

- backstitch (p. 16)
- chain stitch (p. 18)
- woven wheel (p. 18)
- satin stitch (p. 19)
- straight stitch (p. 20)

TIP

Choose a medium-weight craft cotton or linen. This is a good project for using an antique fabric, so look out for old bedlinens or a tablecloth with a large enough undamaged area for this project.

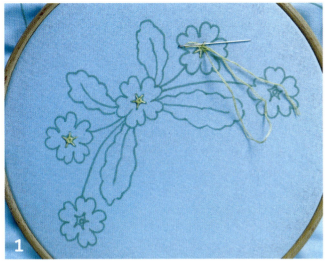
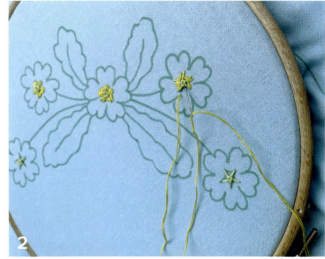
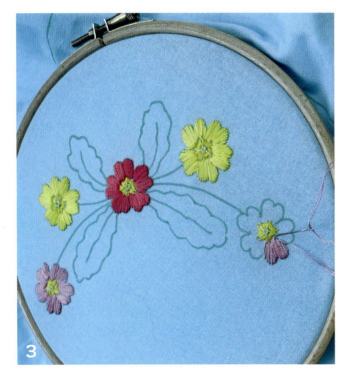
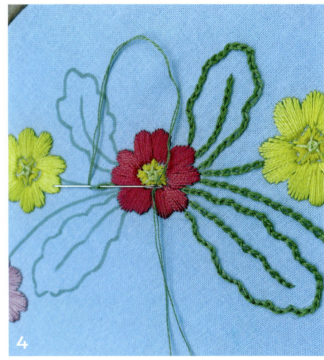

EMBROIDERING THE MOTIFS

Use two strands of thread throughout

1. Mark the tray size on your cloth and draw a wavy line inside the outline by drawing around a saucer or a similar object. Transfer the outline of the tray cloth motif (page 23) onto opposite corners of your fabric, 1³⁄₁₆in (3cm) from the edge. Draw a single flower on the remaining corners. Place the fabric in a hoop large enough to accommodate the corner design. Using tea green 16, embroider a woven wheel in the centre of each flower, beginning each one with five straight-stitch 'spokes'.

2. Using sunshine yellow 444, create a rough star shape with straight stitches radiating out from the centre of each flower.

3. Now fill in the petals of each flower in satin stitch. Use rose red 891 for the central flower, primrose 307 for those on either side, and deep rose 3806 for the remaining two.

4. Use emerald green 702 and chain stitch for the stems and to outline the leaves and leaf veins.

 Remove the fabric from the hoop and erase the lines, if you have used an erasable marker. Press the work on the reverse, following the pressing guidelines on page 11.

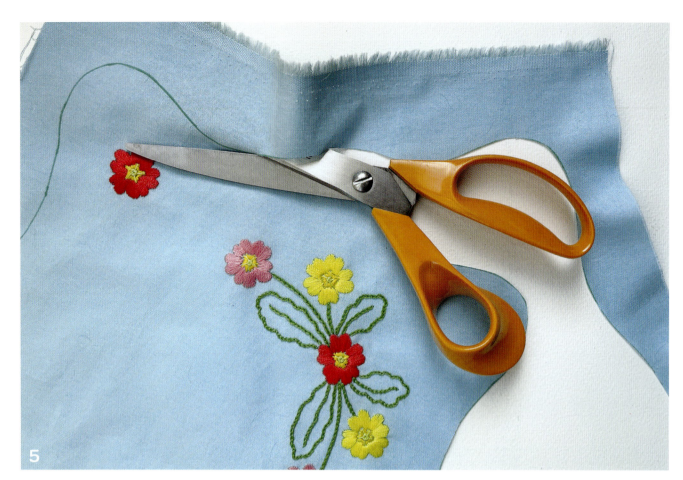

MAKING THE CLOTH

5. Cut out the tray cloth along its wavy outline.

6. Now bind the cut edge with bias binding. For a neat result, do this in two stages. For the first stage, open out the binding and, with the embroidered fabric right side up, line up the edge of the bindng with the edge of the fabric. Stitch along the fold, using matching thread and backstitch.

7. Fold the binding over to the wrong side and slipstitch the folded edge in place. Press.

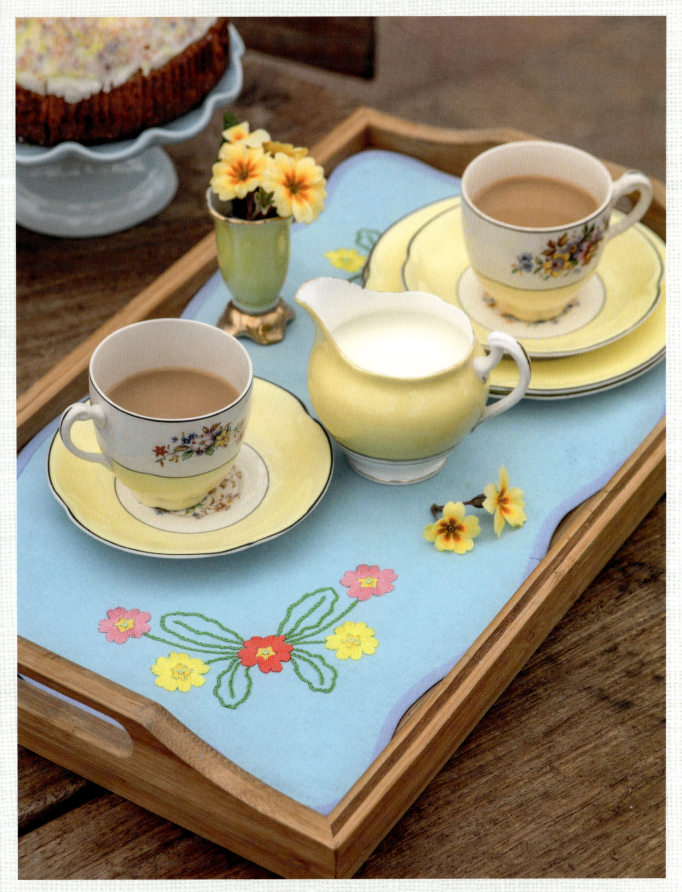

KITCHEN GARDEN

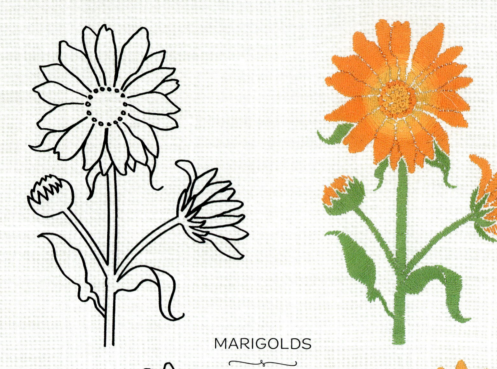

MARIGOLDS

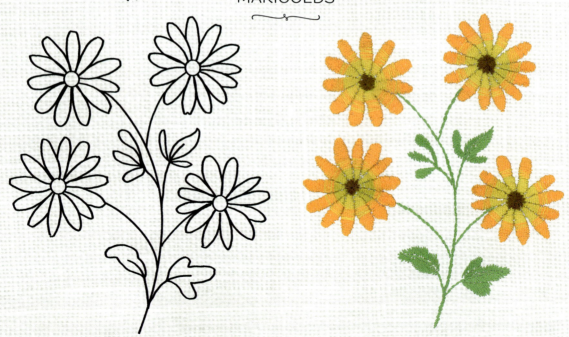

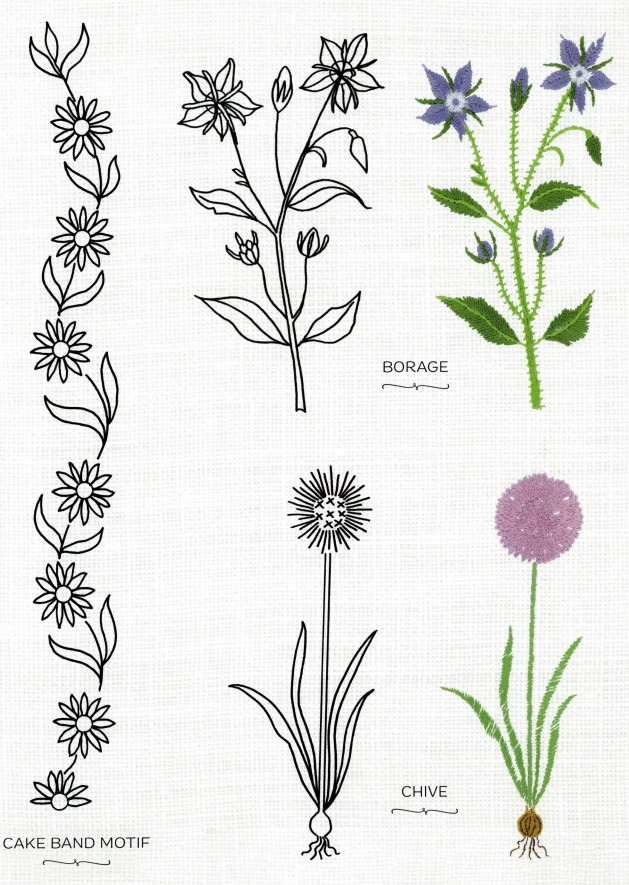

CAKE BAND MOTIF

BORAGE

CHIVE

KITCHEN GARDEN

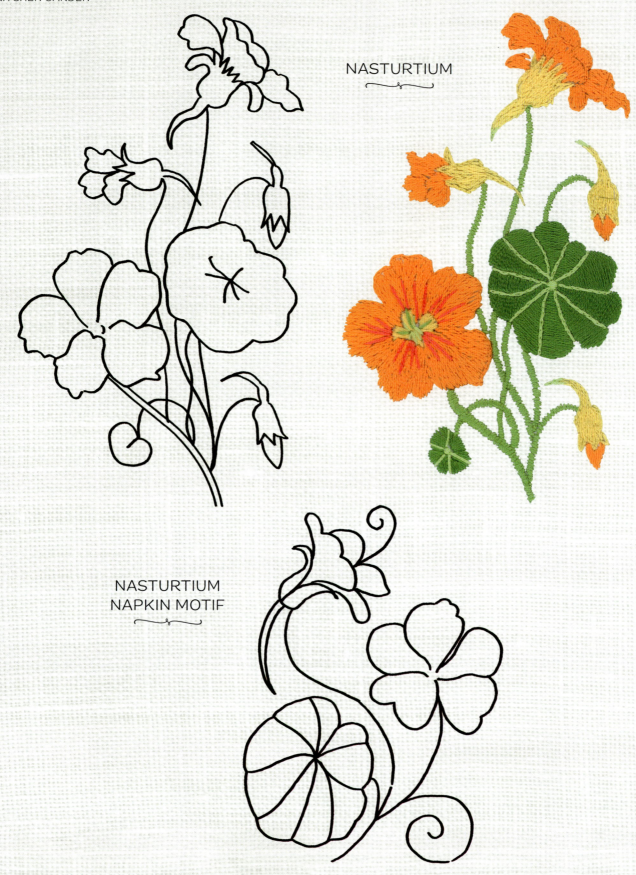

NASTURTIUM

NASTURTIUM
NAPKIN MOTIF

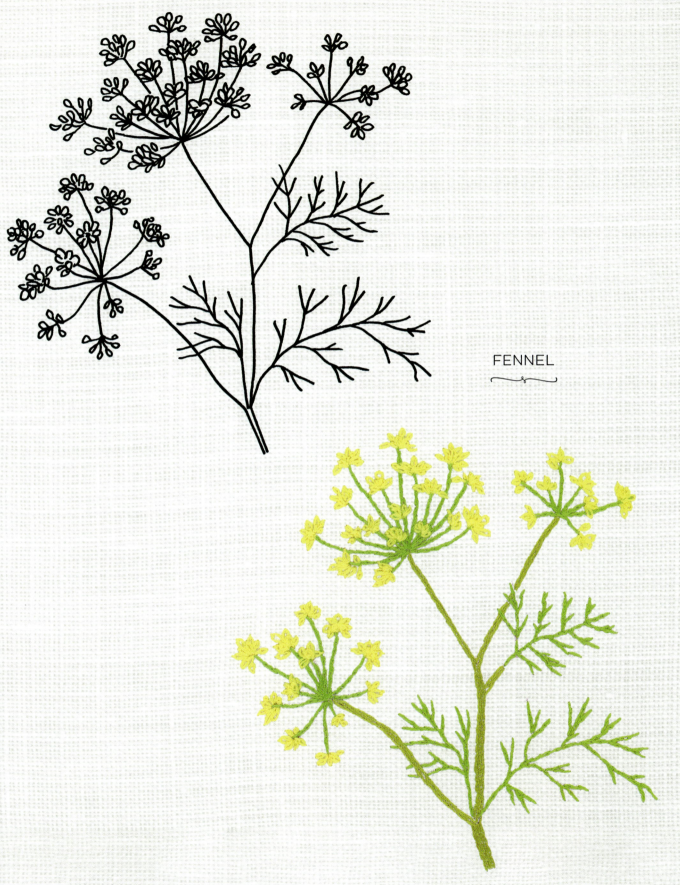

FENNEL

MARIGOLD CAKE BAND

Add a personal touch to a celebration cake with an embroidered band that can be used again and again on all kinds of special occasions. Featuring bright marigolds, it will add a beautiful splash of colour to the party table.

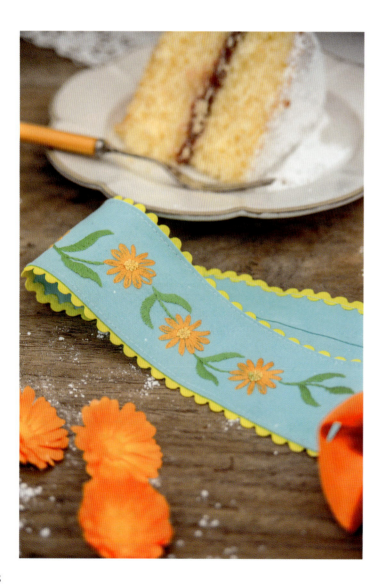

YOU WILL NEED

- Cotton, medium-weight, approximately 24 × 9in (61 × 23cm)
- DMC six-stranded thread:
 emerald green 702
 marigold 741
 dandelion 743
- Embroidery hoop
- Crewel (embroidery) needle
- Erasable marker; ballpoint pen
- Pins
- Ricrac braid, 48in (1.2m) long
- Sewing thread to match fabric
- Ribbon, 1in (2.5cm) wide × 40in (1m)

STITCHES USED

- chain stitch (p. 18)
- French knots (p. 18)
- satin stitch (p. 19)
- stem stitch (p. 20)
- straight stitch (p. 20)

TIP

The measurements given here are for a band to fit a cake 7in (18cm) diameter. It would be easy to make a longer band for a larger cake: just allow more fabric and repeat the motif as many times as necessary.

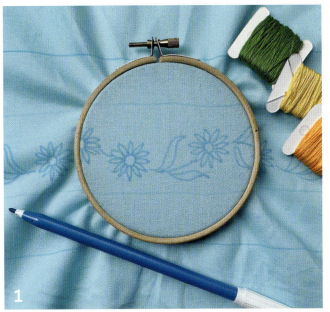
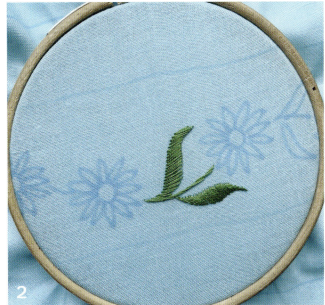
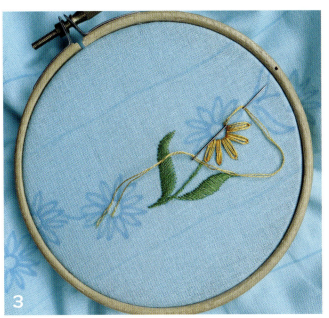
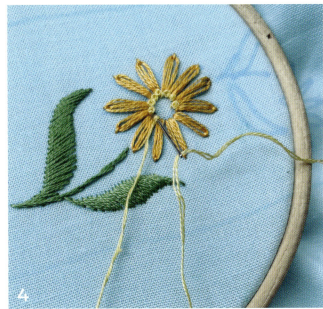

EMBROIDERING THE MOTIFS

Use two strands of thread throughout

1. Draw two parallel lines, 22¾in (58cm) long, 2in (5cm) apart, across the centre of the fabric. Draw two other lines parallel to these, 1⅜in (3.5cm) above and below. Trace or transfer the marigold design from page 34, positioning it within the central strip and repeating along the length of the strip. The marks should be erasable, as they are unlikely to be completely covered by the embroidery.

2. Place the fabric in an embroidery hoop. Using emerald green 702, embroider the stems in stem stitch and the leaves in satin stitch.

3. Using marigold 741, embroider the petals. For each petal, stitch a detached chain, then add a straight stitch in the centre of the loop.

4. Using dandelion 743, fill the centre of each flower with French knots. Once the whole design has been embroidered, remove the fabric from the hoop and erase the drawn lines, apart from the outer lines, then press the work on the reverse, following the pressing guidelines on page 11.

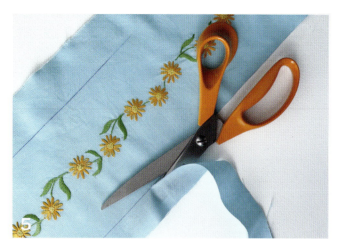
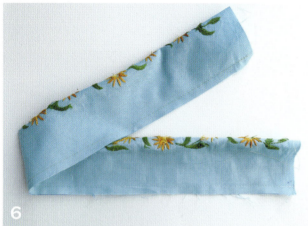

MAKING THE BAND

5. Cut out the band and fold it in half lengthways, right sides together, lining up the edges.

6. Stitch the long sides together, ⅜in (1cm) from the edge, to form a tube. Leave the two short ends unstitched.

7. Turn right sides out and press flat, with the seam down the centre back.

8. Cut the ricrac braid into two equal lengths; do the same with the ribbon. Pin the ricrac along the two long edges. Insert one end of each length of ribbon into the short ends of the cake band and pin in place. Topstitch all round the band to secure the trims in place.

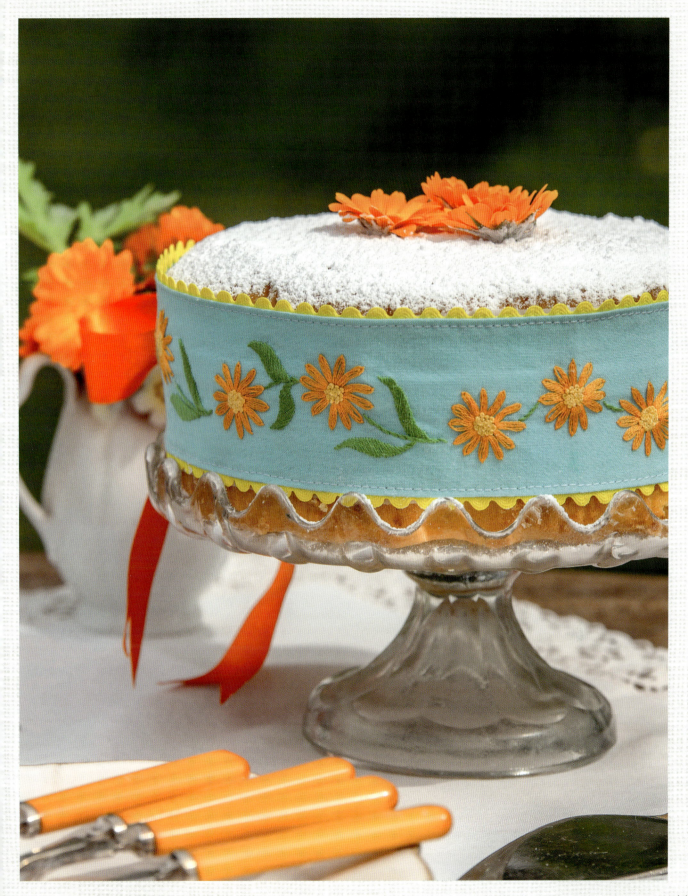

NASTURTIUM NAPKIN

Nasturtiums are a colourful addition to the kitchen garden and all parts can be eaten: the flowers, leaves and the young seed pods. Here they are used to adorn a napkin to use at the table, on a picnic or as a tray cloth.

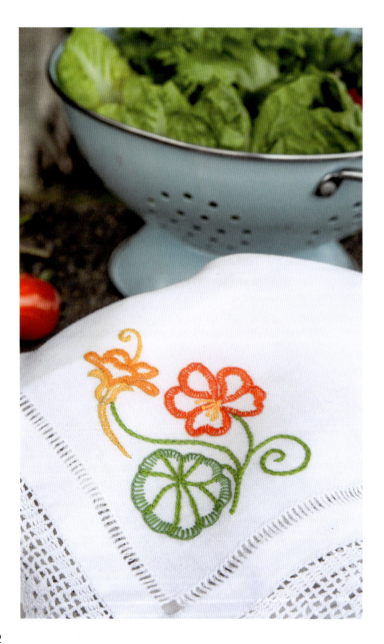

YOU WILL NEED

- Cotton or linen napkin, any size
- DMC six-stranded thread:
 apple green 907,
 fern green 703,
 marigold 741,
 deep orange 608,
 dandelion 743
- Embroidery hoop
- Crewel (embroidery) needle
- Permanent marker
 (such as a ballpoint pen)

STITCHES USED

- blanket stitch (p. 17)
- chain stitch (p. 18)
- French knots (p. 18)
- stem stitch (p. 20)
- straight stitch (p. 20)

TIPS

- This design can be added to a napkin or tray cloth of any size, as long as it fits comfortably into one of the corners.

- You can choose to use either a permanent or an erasable marker to draw the design. Some of the stitches are quite open and may not cover the marks, so bear this in mind when deciding which type of marker to use.

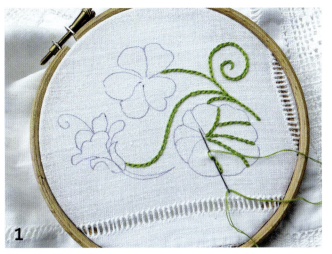
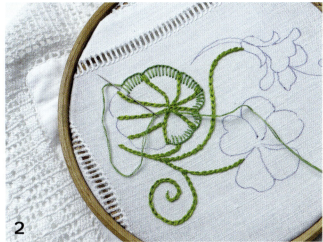
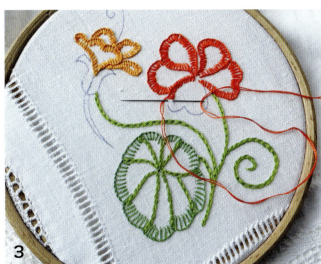
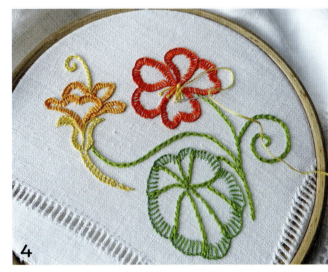

EMBROIDERING THE MOTIF

Use two strands of thread throughout

1. Trace or transfer the nasturtium napkin motif from page 36 on to the napkin, positioning it on one corner. The marks can be made with a permanent or an erasable marker. Place the fabric in an embroidery hoop and use apple green 907 to embroider the stems and leaf veins in chain stitch, keeping the stitches small and even.

2. Thread the needle with two strands of fern green 703 and outline the leaf in blanket stitch. Form the stitches quite close together; vary the stitch length but keep the spacing even.

3. Using marigold 741, outline the petals of the smaller flower in buttonhole stitch. Outline the petals of the larger flower using deep orange 608.

4. Using dandelion 743, outline the calyx spur and the sepals at the base of the smaller flower using a combination of blanket stitch and stem stitch. Using the same colour, embroider the curled protuberance – the style – with chain stitch. On the larger flower, add straight stitches radiating from the centre to suggest stamens, topping each one with a French knot and adding a single French knot in the flower centre.

CREATIVE IDEAS

Using stitches to outline the shapes in this design makes it relatively quick and easy to stitch. The design would lend itself to all kinds of applications – not just table linen but clothing, such as the yoke of a shirt or the hem of a skirt. It would also look good repeated along the lower edge of a café curtain.

BRIGHT AND BEAUTIFUL

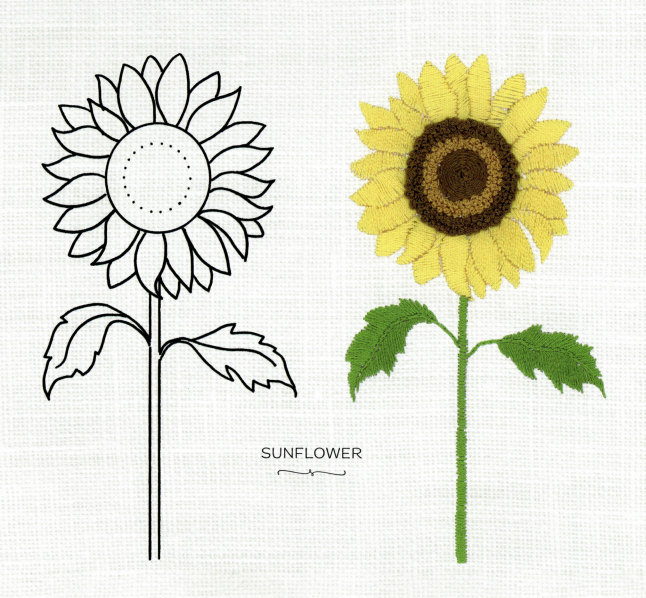

SUNFLOWER

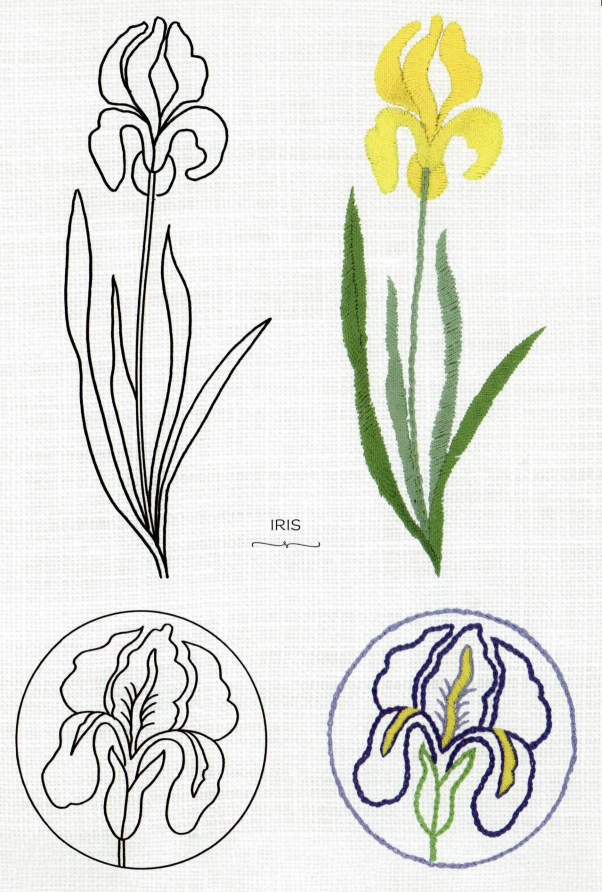
IRIS

MOTIFS

45

LILY

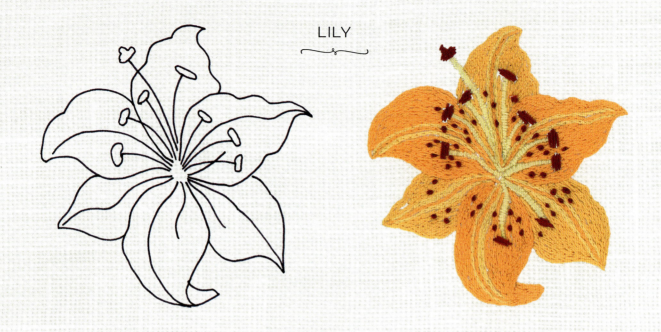

LILY FRAME MOTIF

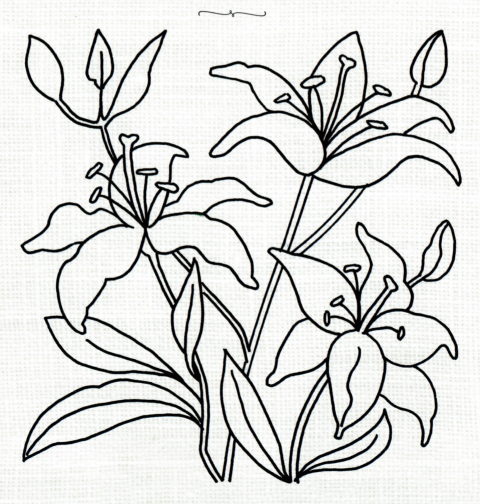

LILY

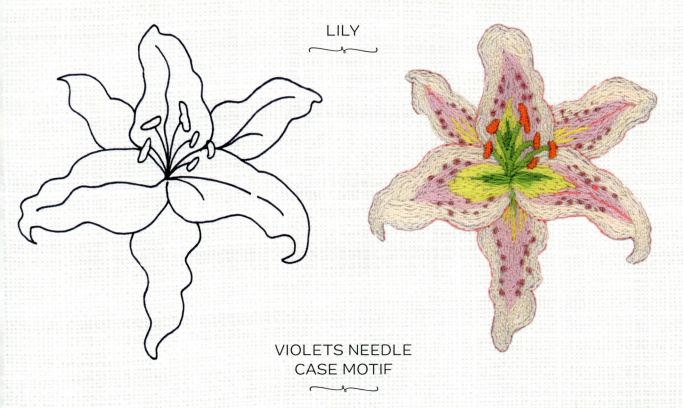

VIOLETS NEEDLE CASE MOTIF

LILY FRAMED PICTURE

Put your embroidery skills on display with this attractive picture that would look at home in any room in the house. The stargazer lily doesn't feature in the Victorian language of flowers but, as it resembles a star, which is a common symbol of prosperity in some cultures, it represents abundance and good fortune.

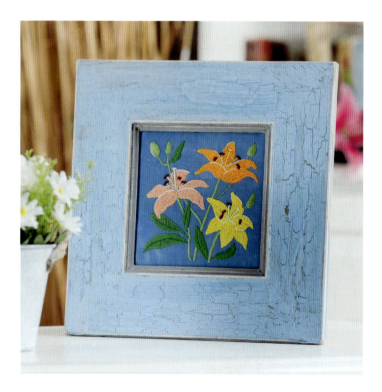

YOU WILL NEED

- Cotton or linen fabric, at least 10in (25cm) square
- Lightweight wadding or felt, 6in (15cm) square
- DMC six-stranded thread:
 fern green 703
 forest green 701
 apricot 742
 marigold 741
 pale primrose 445
 buttercup 973
 shell pink 353
 peach 3341
 dark cherry 3802
 white B5200
- Embroidery hoop, 7in (18cm) diameter
- Crewel (embroidery) needle
- Permanent or erasable marker
- Strong thread
- Picture frame with 6in (15cm) square aperture
- Thick card
- Fabric glue

STITCHES USED

- bullion stitch (p. 19)
- overcast stitch (p. 19)
- satin stitch (p. 19)
- split stitch (p. 20)
- split stitch filling (p. 20)

TIP

Choose a frame with a square aperture of 6in (15cm). The frame shown here measures 11in (28cm) square and the glass has been removed. You may prefer to display your handiwork behind glass, in which case try to choose a frame with enough depth to ensure that the surface of the embroidery doesn't touch the glass.

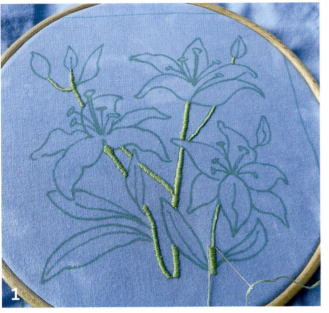
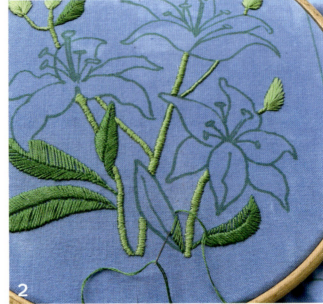
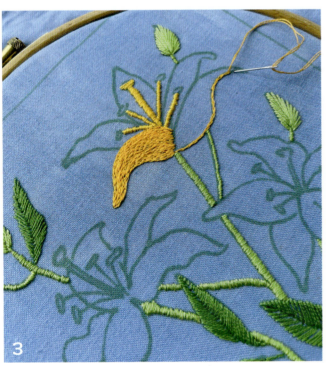
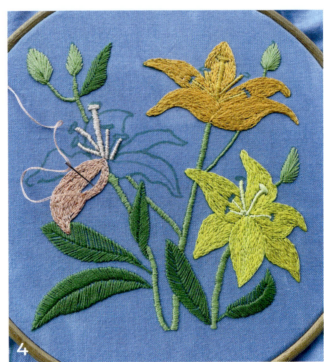

EMBROIDERING THE MOTIF

Use two strands of thread throughout

1. Transfer or trace the lily frame motif from page 46 to the centre of the fabric. Place the fabric in a hoop. Using fern green 703, embroider the flower stems in overcast stitch.

2. Working in satin stitch, fill in the buds using fern green 703 and the leaves using forest green 701.

3. Work the pistil and stamens in overcast stitch. For the top flower, use apricot 742. Then stitch the petals in split stitch filling using marigold 741.

4. Embroider the other two flowers in a similar way. For the yellow flower, use pale primrose 445 for the pistil and stamens and buttercup 973 for the petals. For the peach-coloured flower, use shell pink 353 for the stamens and peach 3341 for the petals.

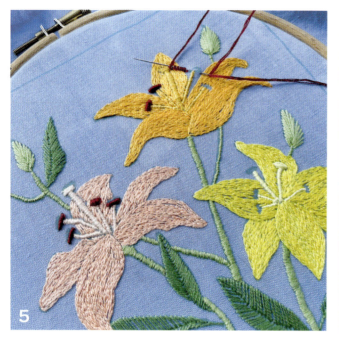
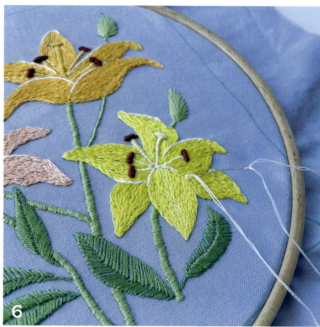
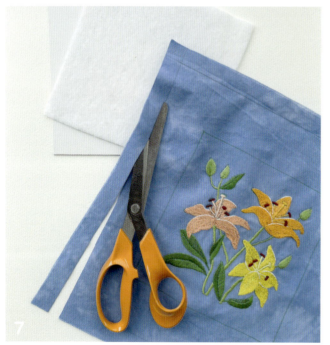
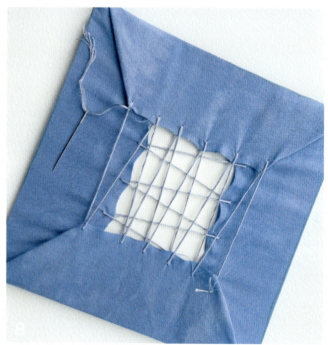

5. Use 3802 and bullion stitch for the anthers.

6. Finally, outline the top edge of some of the petals, particularly where they overlap, with white B5200 and split stitch. When all the embroidery is complete, remove the work from the hoop. If necessary, rinse in tepid water to remove any drawn marks. Leave to dry, then press.

7. Trim the fabric to measure 10in (25cm). Cut a piece of card 6in (15cm) square and a piece of wadding or felt to the same dimensions.

8. Attach the felt to the card with a little glue. Place felt side down on the centre back of the embroidered fabric. Using strong thread, fold the fabric over the edges of the card and lace the edges together, working outwards from the centre on each side and pulling the thread taut so that the fabric is stretched firmly across the padded cardboard. It is now ready to place inside the frame.

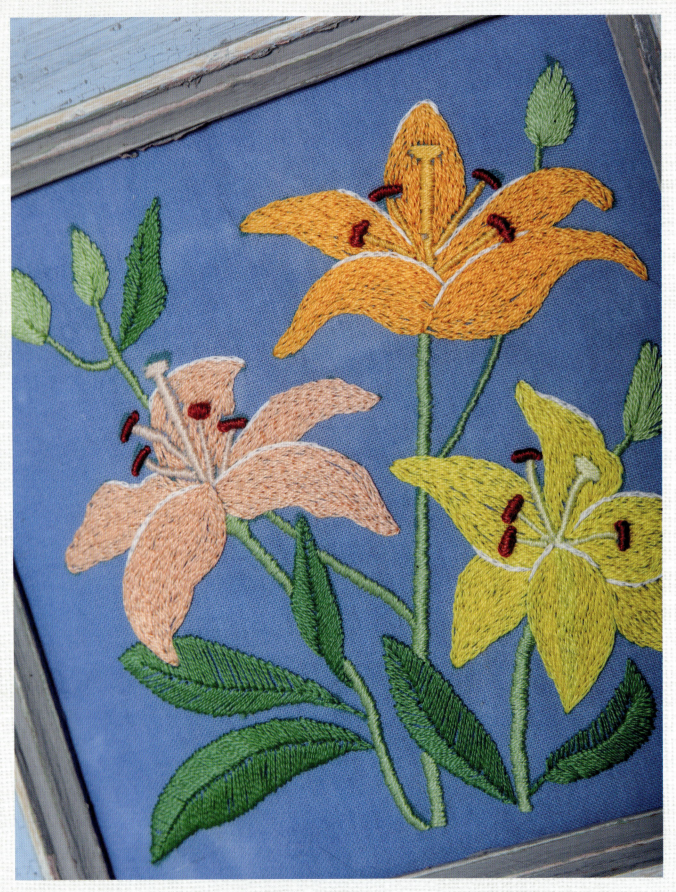

VIOLETS NEEDLE CASE

Everyone needs a place to keep needles and pins. A needle case keeps everything safe and handy, and takes up very little space in the sewing box. This one, embellished with dainty violets, is pretty as well as practical.

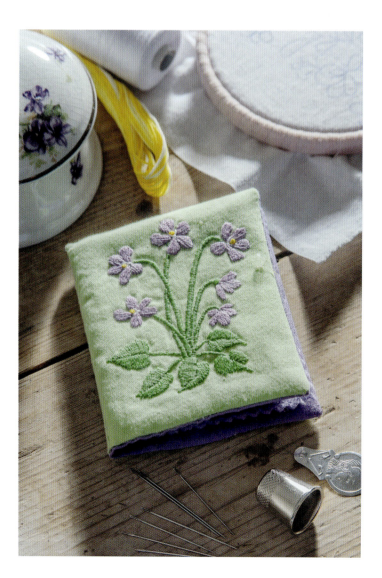

YOU WILL NEED

- Cotton or linen fabric, approximately 10 × 8in (25 × 20cm)
- Lining fabric, at least 7 × 4¼in (18 × 11cm)
- DMC six-stranded thread:
 lilac 209
 emerald green 702
 sunshine yellow 444
- Embroidery hoop
- Crewel (embroidery) needle
- Permanent or erasable marker
- Fusible wadding, 6 × 3⅛in (15 × 8cm)
- Felt pieces in two colours, each 5¾ × 3in (14.5 × 7.5cm)
- Pinking shears (optional)

STITCHES USED

- fly stitch (p. 18)
- French knot (p. 18)
- overcast stitch (p. 19)
- satin stitch (p. 19)
- split stitch (p. 20)

TIP

This is a good way to use small remnants of fabric left over from other projects.

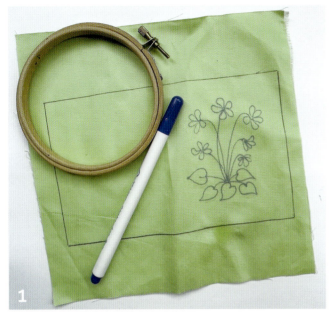
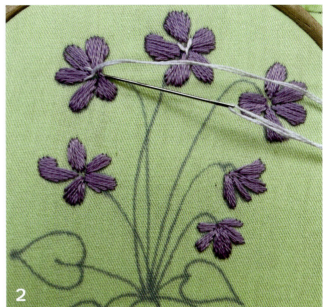
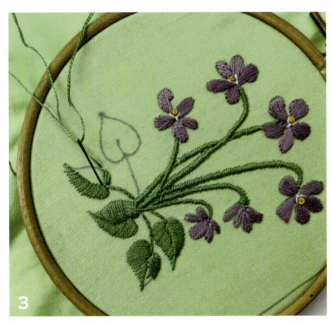
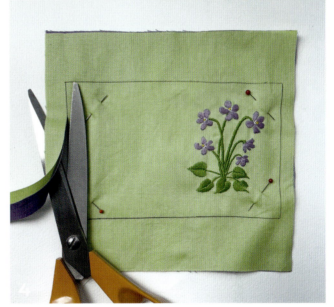

EMBROIDERING THE MOTIF

Use two strands of thread throughout

1. Measure and mark out a rectangle 6¼ × 3½in (16 × 9cm), using a permanent marker. Trace or transfer the violets needle case motif (page 47), using either an erasable or permanent marker, positioning it towards the right of the rectangle.

2. Place the fabric in an embroidery hoop. Using lilac 209, fill in each petal in satin stitch. Then using white B5200, embroider a small fly stitch in the centre of each of the four largest flowers, and add a French knot in sunshine yellow 444.

3. Embroider the main stems using emerald green 702 and overcast stitch. For the smaller leaf stems use split stitch, then fill in the leaves in satin stitch. Remove the fabric from the hoop and erase the drawn lines. Press the work on the reverse, following the pressing guidelines on page 11.

MAKING THE CASE

4. Pin the embroidered fabric and lining together and cut out.

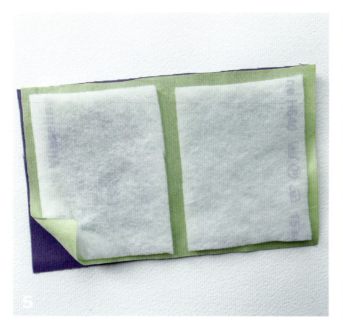
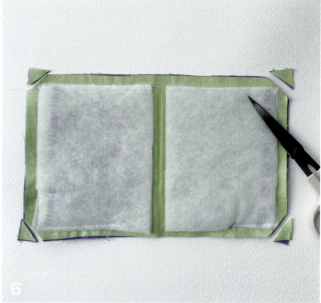
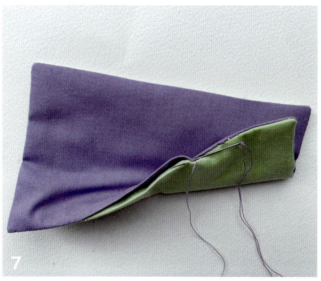
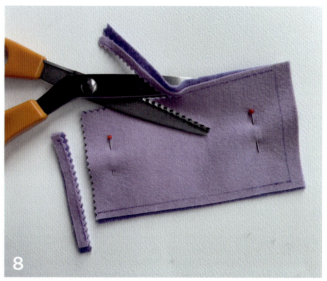

5. Place the two fabrics with right sides together. Cut the fusible wadding in half and apply these on top, with a small gap between them in the centre. Cover with a pressing cloth or kitchen paper and fuse in place with a hot iron.

6. Stitch all round, with a 5/16in (8mm) seam allowance, leaving a small gap in the centre of the lower edge, for turning. Trim the corners of the fabrics close to the sewn edge.

7. Turn right sides out and press, tucking in the raw edge on the opening; slipstitch the folded edges together.

8. Trim the edges of the felt pieces using pinking shears, if you wish, then place them on top of each other on the inside of the case, and stitch down the centre, through all layers.

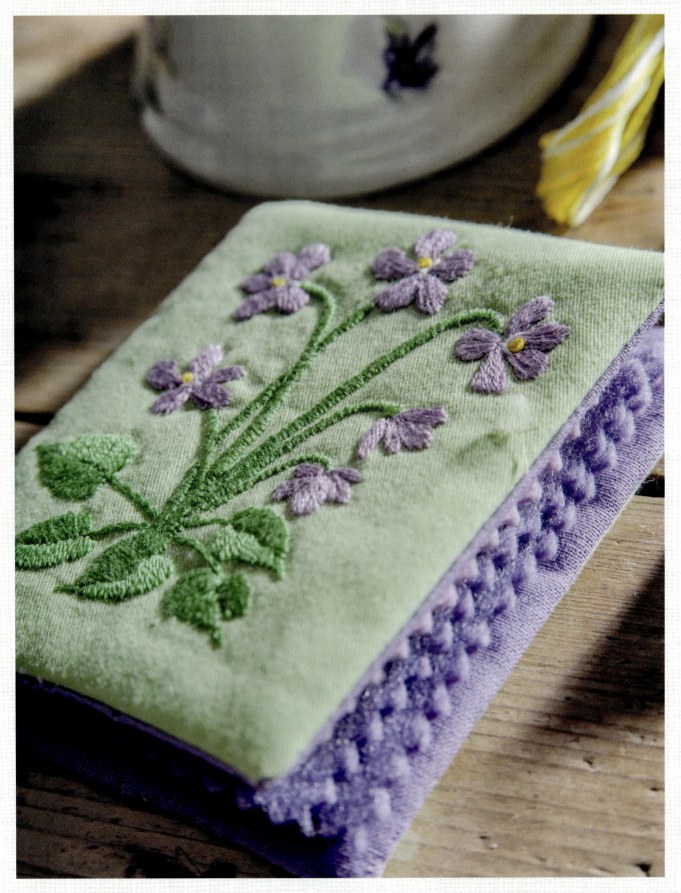

COTTAGE GARDEN

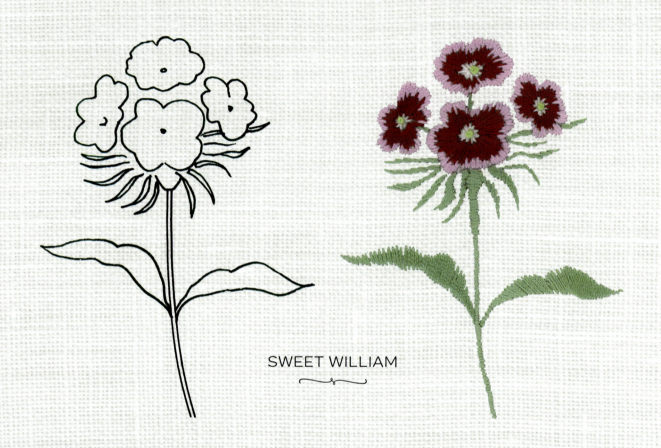

SWEET WILLIAM

SWEET WILLIAM
BABY DRESS MOTIF

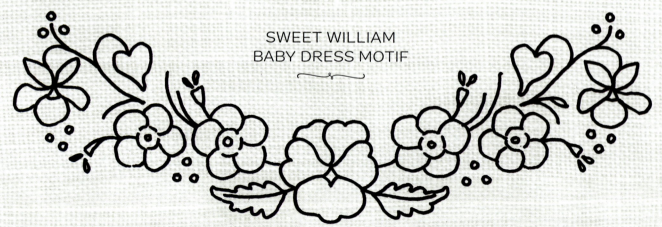

MOTIFS

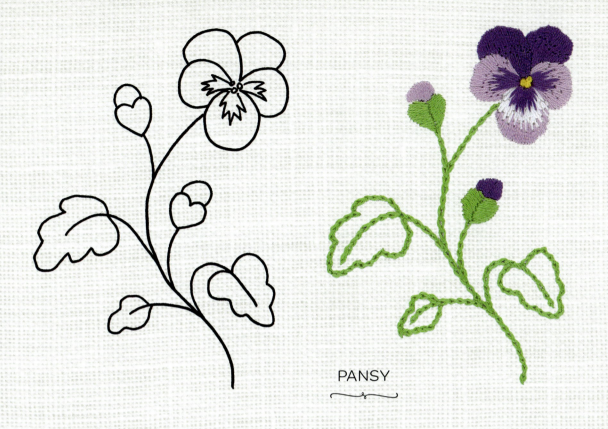

PANSY

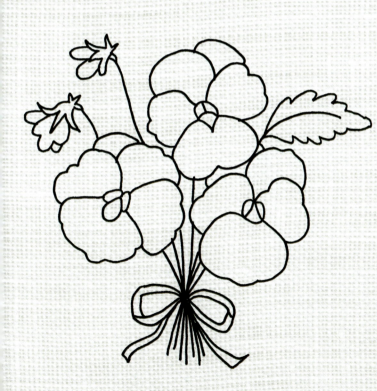

PANSY HOOP MOTIF

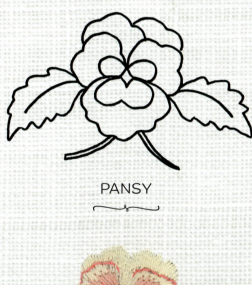

PANSY

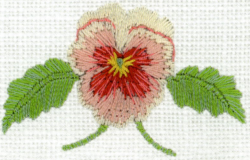

COTTAGE GARDEN

DELPHINIUM

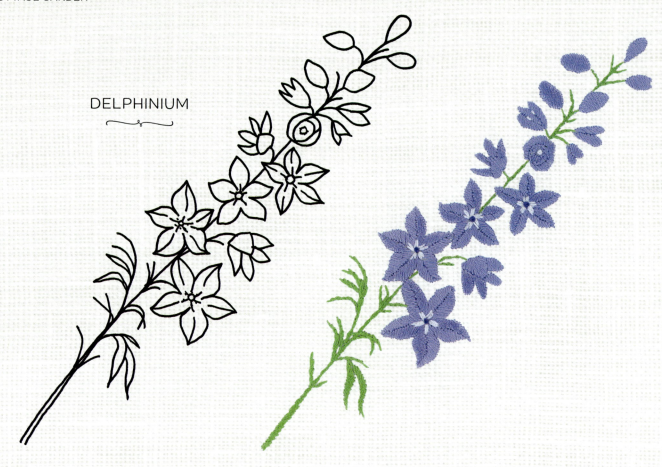

APPLE BLOSSOM

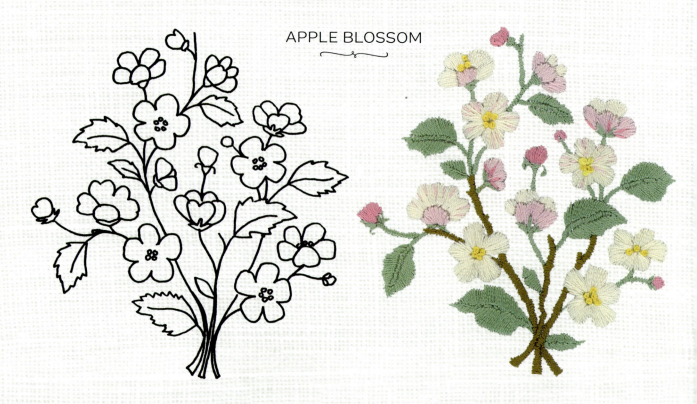

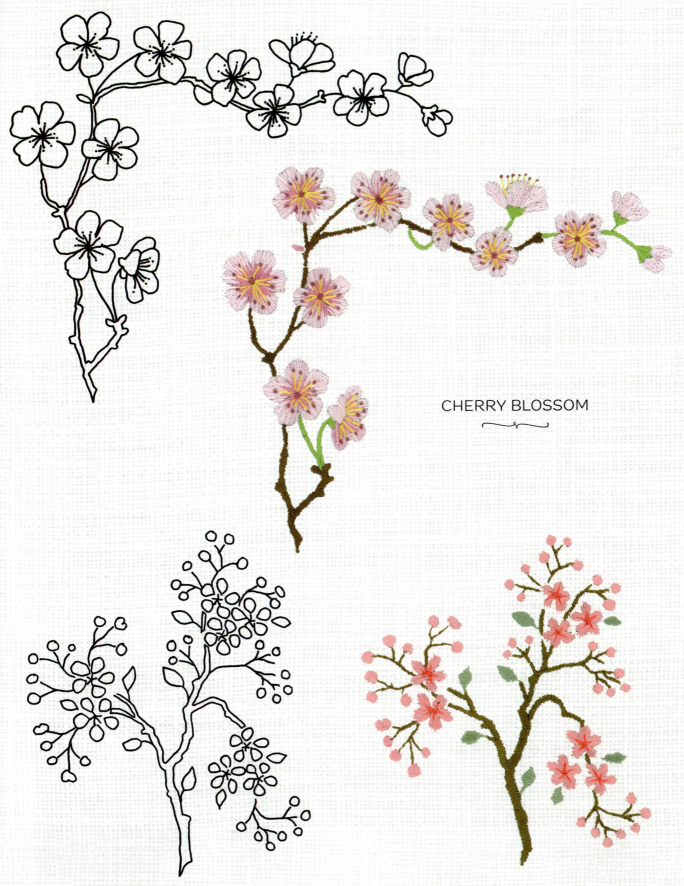

CHERRY BLOSSOM

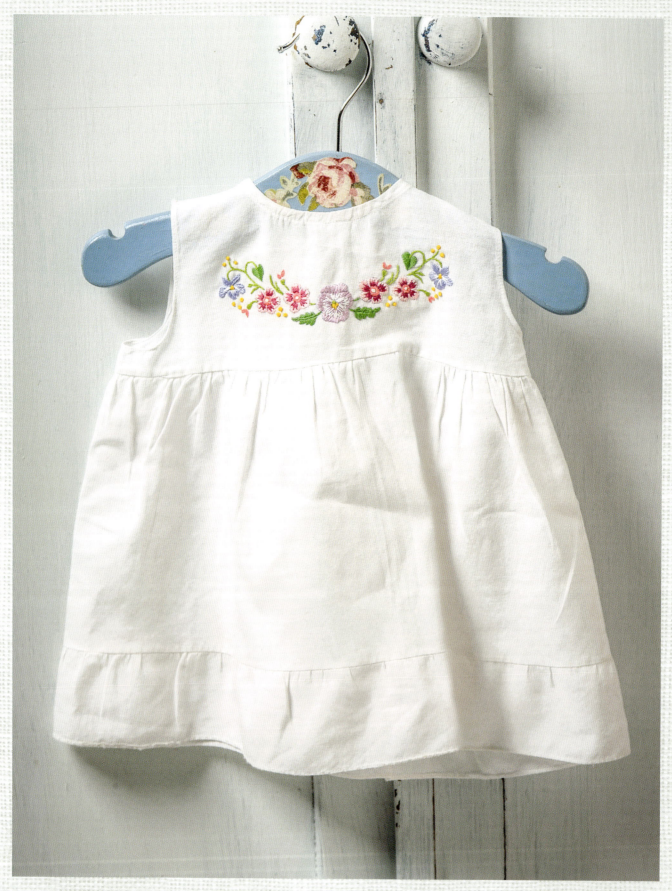

SWEET WILLIAM BABY DRESS

These dainty flowers embroidered across the bodice of a cotton dress would make a lovely gift for a new baby.

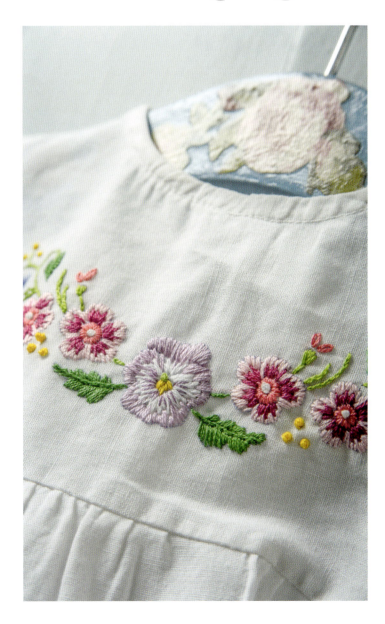

YOU WILL NEED

- Cotton dress
- DMC six-stranded thread:
 sunshine yellow 444
 white B5200
 heather pink 554
 apple green 907
 amethyst 553
 emerald green 702
 bubblegum 956
 red-violet 718
 cherry blossom 605
 cornflower blue 340
- Embroidery hoop
- Crewel (embroidery) needle
- Erasable marker

STITCHES USED

- chain stitch (p. 18)
- French knot (p. 18)
- long and short stitch (p. 19)
- satin stitch (p. 19)
- split stitch (p. 20)
- stem stitch (p. 20)
- straight stitch (p. 20)

TIP

Antique shops, fairs and car boot sales are a good source of baby clothes. Of course, you could buy a brand-new one or even make your own.

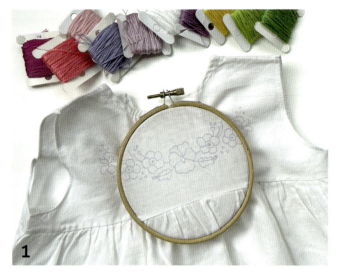
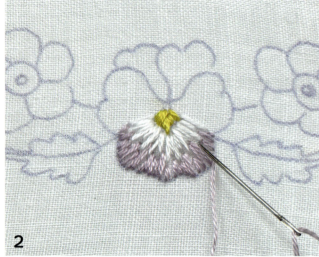
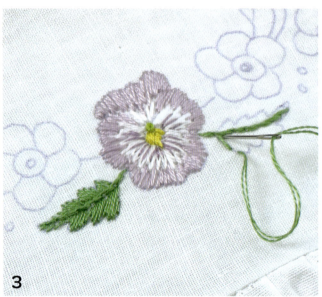
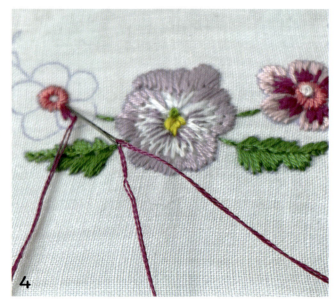

EMBROIDERING THE MOTIF

Use two strands of thread unless otherwise stated

1. Trace or transfer the baby dress motif from page 56 on to the yoke of the dress. A ballpoint pen is good for this. Select your colours and place the fabric in an embroidery hoop. You will need a small hoop that can be moved from place to place to work on different areas of the design.

2. Start with the pansy. Fill in the centre in satin stitch, using two strands of sunshine yellow 444. Working on one petal at a time, work in long and short stitch, using two strands of white B5200, with stitches fanning out from the flower centre. Then complete the petal in long and short stitch, using two strands of heather pink 554.

3. Make a French knot in the centre of the flower using apple green 907, then add a few fine lines to the lower petals using a single strand of amethyst 553. Using two strands of emerald green 702, embroider the two leaves on either side of the pansy: stem stitch down the centre and satin stitch on either side.

4. For the sweet William flowers, fill in the central ring with satin stitch using bubblegum 956. Embroider a few long and short stitches radiating out from this, using red-violet 718, then fill in the rest of each petal in long and short stitch, using cherry blossom 605. Make a French knot in the centre of the flower, using white B5200.

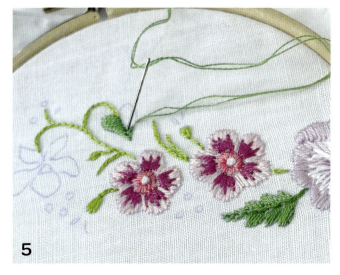

5

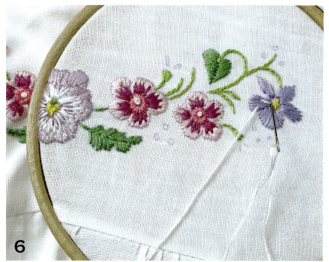

6

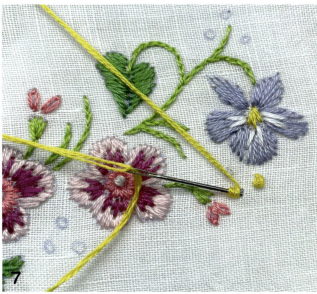

7

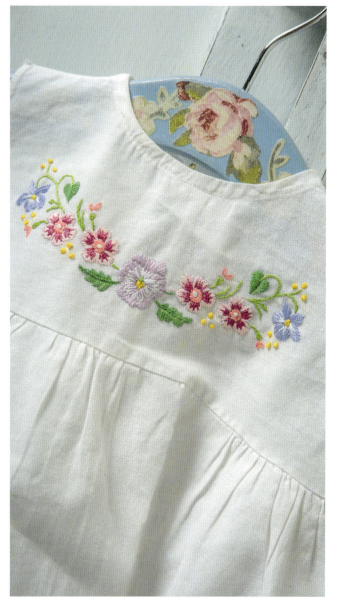

5. Using apple green 907, embroider the stems in split stitch and the tiny leaves in satin stitch. Fill in the heart-shaped leaves in satin stitch using emerald green 702.

6. Fill in the centre of the violet in satin stitch using sunshine yellow 444 and the petals using cornflower blue 340. Add a couple of straight stitches, in white, to the lower petals.

7. Add detached chain stitches using bubblegum 956 to suggest buds, then add a scattering of French knots in sunshine yellow 444.

PANSY HOOP

Pansies are a very decorative flower, with lots of varieties, many of them with multicoloured markings on the petals. This motif features a little bunch tied with a ribbon bow, perfect for framing.

YOU WILL NEED

- White cotton fabric, approximately 8in (20cm) square
- DMC six-stranded thread:
 fern green 703
 sunshine yellow 444
 porcelain 746
 aubergine 552
 heather pink 554
 pale primrose 445
 grape 3835
 magenta 3837
 cornflower blue 340
 cameo pink 761
 claret 814
- Embroidery hoops, 5in (12cm) and 6in (15cm)
- Crewel (embroidery) needle
- Ruler
- Pencil or ballpoint pen
- White thread
- Acrylic paint
- Paintbrush
- 30in (76cm) length of ribbon, $^3/_{16}$in (5mm) wide

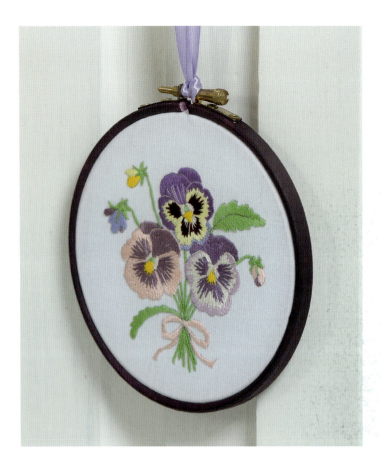

STITCHES USED

- long and short stitch (p. 19)
- overcast stitch (p. 19)
- stem stitch (p. 20)
- straight stitch (p. 20)

TIP

Embroidery hoops are an essential tool when stitching, keeping fabric taut as you sew. They also make a quick, easy and convenient way to display your handiwork, as demonstrated by this delightful framed picture. For this project, use the larger hoop when stitching, then transfer the fabric to the smaller hoop for framing. A plain wooden hoop can easily be painted, using acrylic paints, in a colour to match the embroidery.

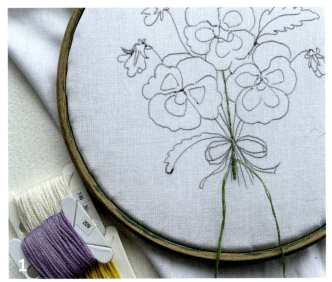
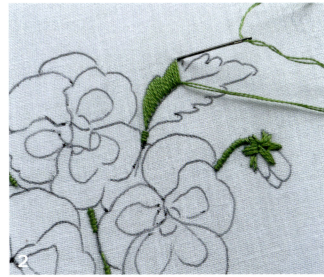
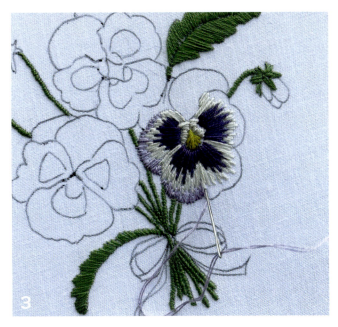
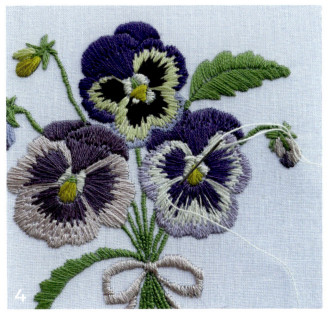

EMBROIDERING THE MOTIF

Use two strands of thread throughout

1. Using a ballpoint pen (or an erasable marker pen, if you prefer), trace the pansy hoop motif from page 57 on to the fabric, placing it centrally. Place the fabric in a 6in (15cm) embroidery hoop. Use fern green 703 to embroider the stems using overcast stitch.

2. With the same colour, fill in the sepals and leaves in satin stitch.

3. Starting with the flower on the bottom right, fill in the centre in satin stitch, using sunshine yellow 444 and porcelain 746. Then, working from the centre outwards, fill in the two side petals and the lower petal in long and short stitch, using aubergine 552, then porcelain 746, then heather pink 554 on the outer edges. Fill in the two upper petals in long and short stitch using only aubergine 552.

4. Fill in the other flowers in a similar way, using the diagram as a colour guide. Fill in the flower buds and the bow using satin stitch. Then, using a single thread in the appropriate colour, add finer details using single straight stitches, and outline the tops of some petals in split stitch, to help them stand out.

Press the embroidered fabric piece on the reverse, if necessary, following the pressing guidelines on page 11.

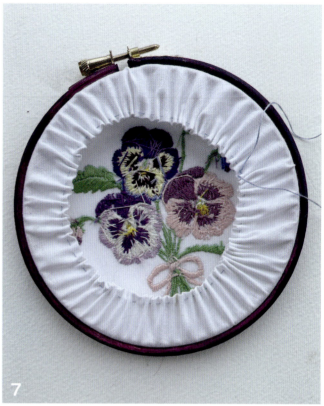

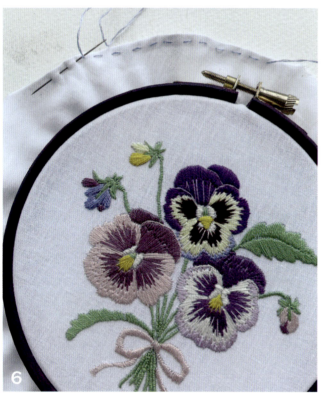

FRAMING THE MOTIF

5. Paint the outer ring of the 5in (12cm) hoop, using acrylic paint to match one of the thread colours. Leave to dry, give it a second coat if desired, then leave to dry completely.

6. Trim the fabric to a circle measuring 3½in (9cm) diameter. Place this on top of the plain wooden ring of the hoop and place the outer ring on top.

Make sure that the embroidered motif is centred within the hoop and press down, then tighten the screw. Using two strands of white thread (a coloured thread has been used here, for clarity), sew a running stitch around the edge of the fabric circle, about ⅛in (3mm) from the edge, folding the raw edge under as you go.

7. Pull the thread ends to gather the fabric tightly, then fasten off securely by tying the thread ends together. Cut a 17¾in (45cm) length of ribbon and pass the two ends under the screw and through the loop of ribbon, to make a hanger. Tie the remaining piece of ribbon in a bow, around the metal screw fitting.

CREATIVE IDEAS

This design would look good on a coloured fabric, such as a pale yellow or pale green. You could use it on the centre panel of a cushion or framed in a traditional picture frame, perhaps with a coloured mount. Pansy flowers are considered to be symbols of love, remembrance, thoughtfulness and nostalgia and are therefore a good choice for a hand-stitched greetings card or gift.

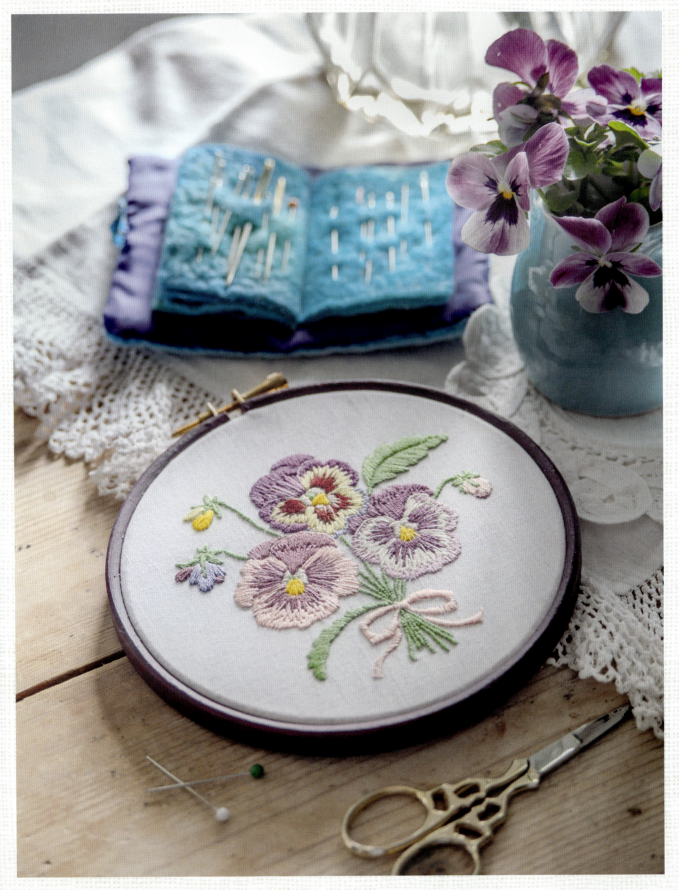

SCENTS OF SUMMER

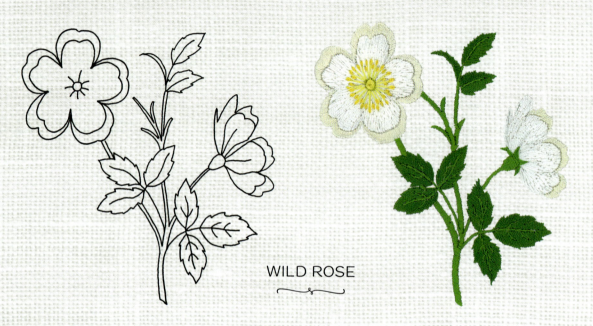

WILD ROSE

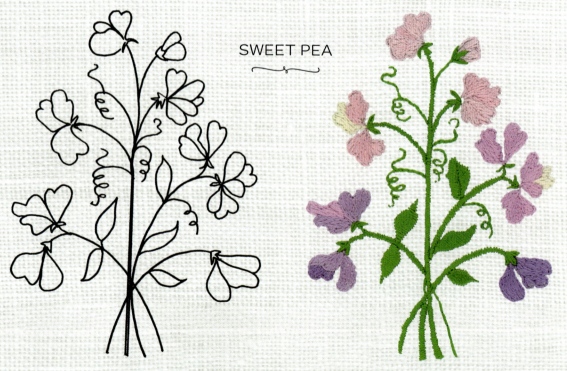

SWEET PEA

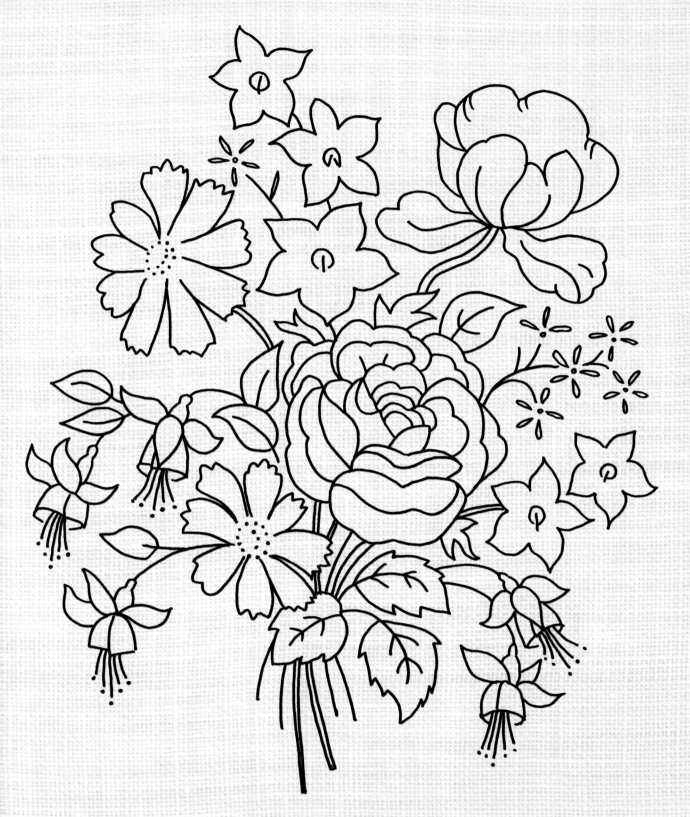

BOUQUET CUSHION MOTIF

SCENTS OF SUMMER

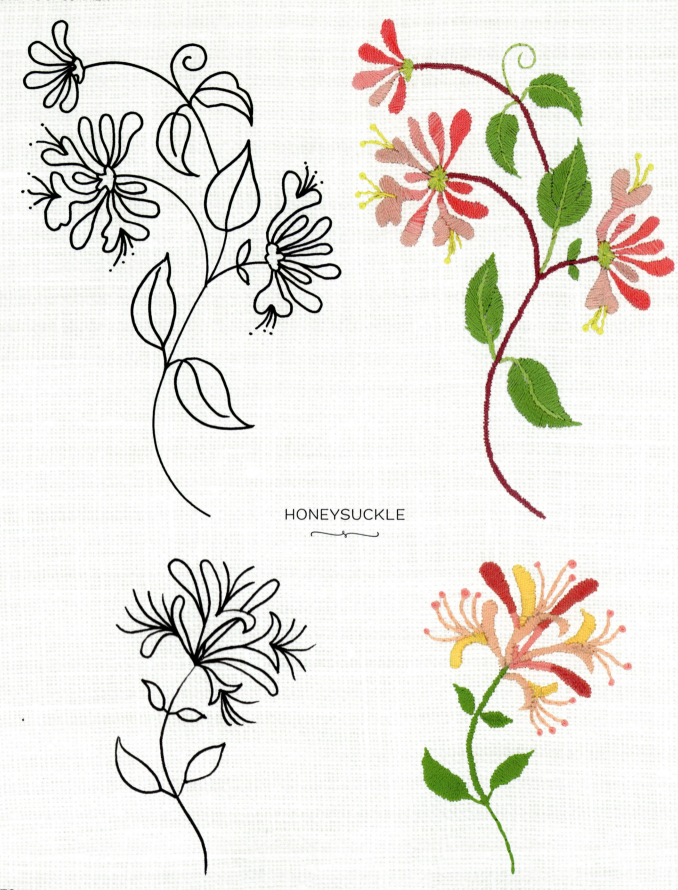

HONEYSUCKLE

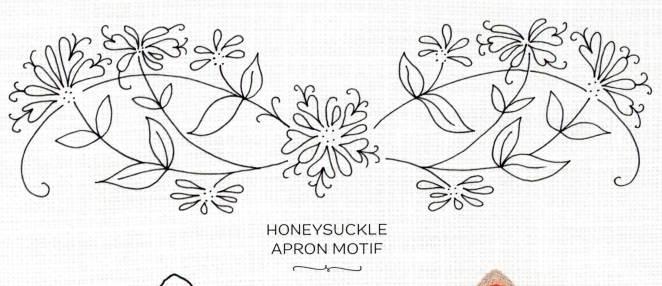

HONEYSUCKLE
APRON MOTIF

ROSE

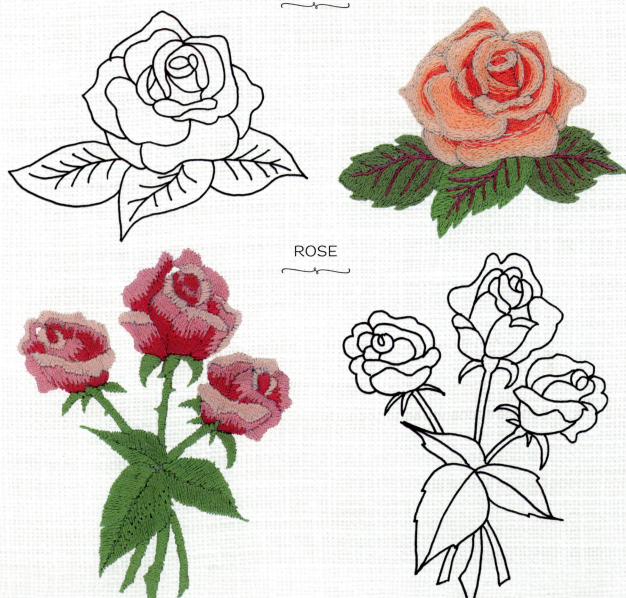

SCENTS OF SUMMER

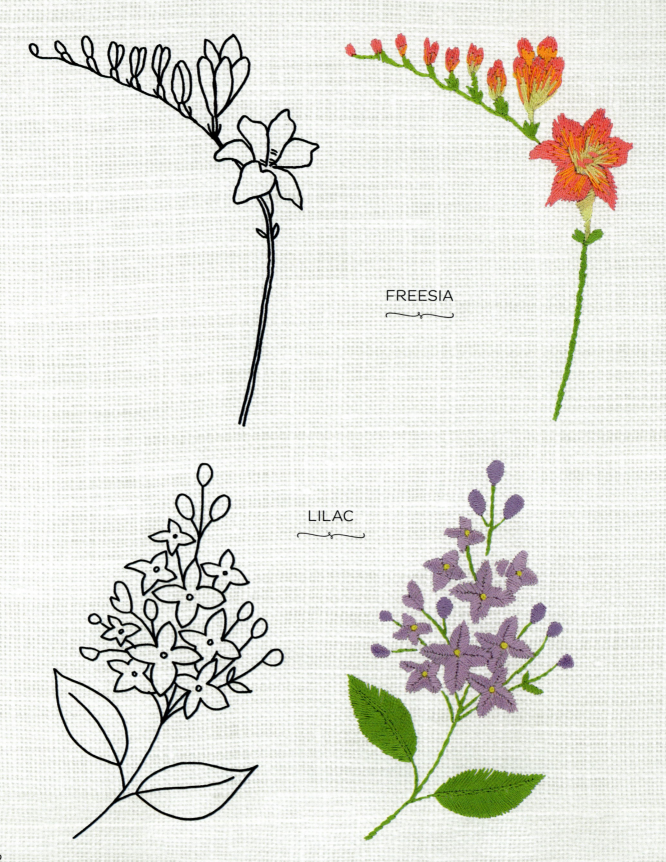

FREESIA

LILAC

HONEYSUCKLE APRON

Decorate a cook's apron with a garland of honeysuckle. This twining plant, with its trumpet-like petals, exudes a heady fragrance. The motif is dainty, with gentle colours that work well against a subtle striped fabric.

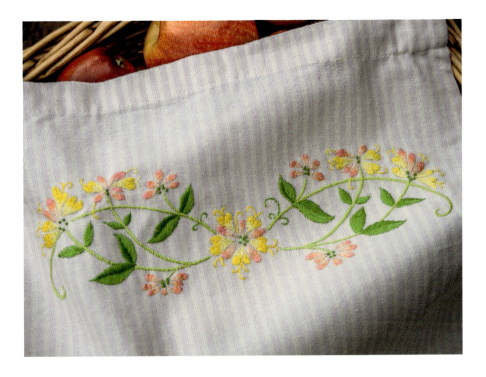

YOU WILL NEED

- Cotton or linen apron
- DMC six-stranded thread:
 tea green 16
 fern green 703
 pale primrose 445
 primrose 307
 shell pink 353
 peach 3341
 sugar pink 894
- Embroidery hoop
- Crewel (embroidery) needle
- Erasable marker

TIP

Choose a plain cotton apron or one with a subtle stripe, like the one shown here. In order for the motif to fit across the yoke, it should be at least 13in (33cm) wide. For a smaller apron, reduce the size of the motif.

STITCHES USED

- backstitch (p. 16)
- fishbone stitch (p. 17)
- French knots (p. 18)
- long and short stitch (p. 19)
- satin stitch (p. 19)
- split stitch (p. 20)
- stem stitch (p. 20)

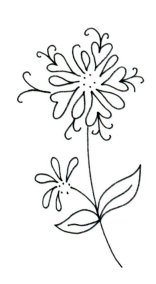

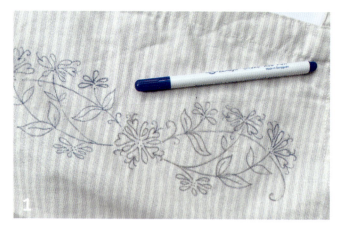
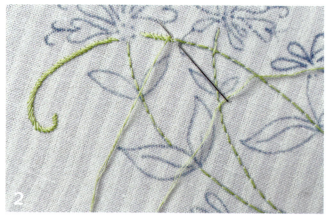
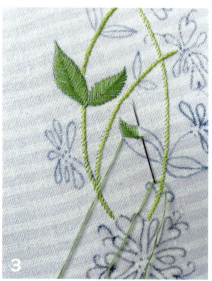
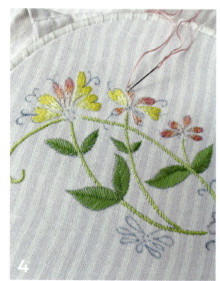
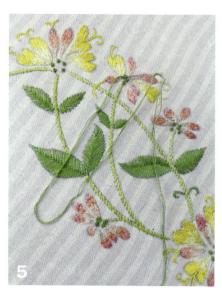

EMBROIDERING THE MOTIF

Use two strands of thread throughout

1. Using an erasable marker, trace the honeysuckle apron motif from page 71 on to the apron, placing it approximately 2¾in (7cm) from the top edge. Place the fabric in an embroidery hoop. You may need to use a hoop that is too small to fit the whole design, so you will need to work on one area at a time and move the hoop when necessary.

2. Thread your needle with two strands of tea green 16 and stitch along the stems in backstitch. Embroider over the lines of backstitch using stem stitch.

3. Using fern green 703, first fill in the larger leaves using fishbone stitch and then fill the smaller leaves using satin stitch.

4. Fill in each petal with long and short stitch, working from the centre outwards and from light to dark. Use pale primrose 445 and primrose 307 on some petals and shell pink 353, peach 3341 and sugar pink 894 on others, using the picture of the finished embroidery as a guide.

5. Using primrose 307, embroider the stamens in split stitch, then, using fern green 703, work clusters of French knots in the flower centres.

Press the embroidered fabric piece on the reverse, if necessary, following the pressing guidelines on page 11.

CREATIVE IDEAS

If you can't find an apron suitable for this project, it is relatively easy to make one. Choose a good-quality thick cotton or cotton-linen blend fabric. For an adult apron, you will need a piece approximately 28in (71cm) wide and 32in (81cm) long, plus extra for a pocket and straps.

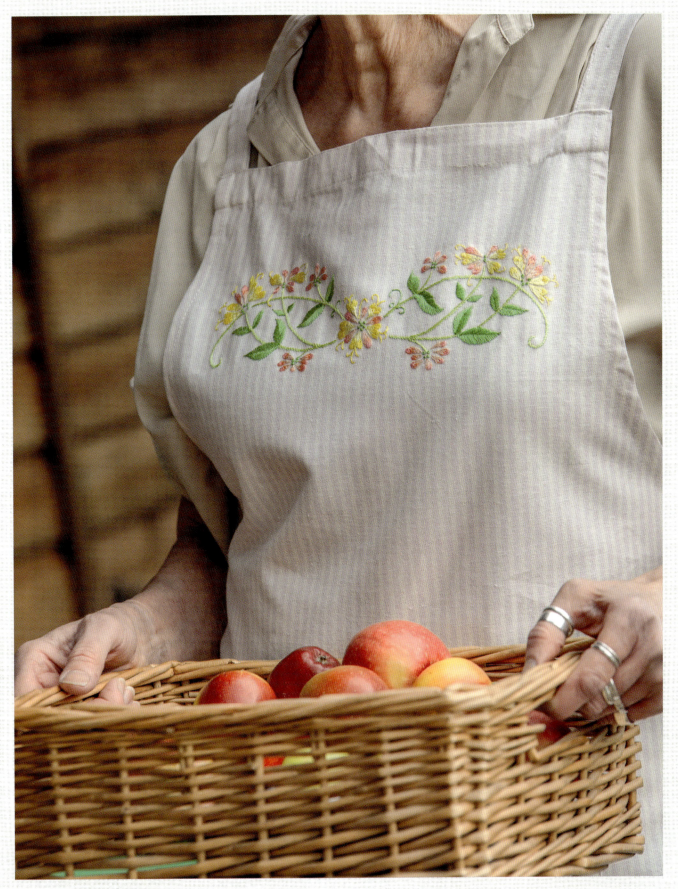

BOUQUET CUSHION

This colourful cushion cover features a beautiful bunch of summer flowers, including a red rose, a poppy and some elegant stems of freesia. It would look lovely on a garden bench, on a patio chair or in a conservatory – or it would bring a burst of summer beauty to any room in the house.

YOU WILL NEED

- Cotton or linen fabric, 14½in (37cm) square
- Backing fabric, 14½ × 15⅜in (37 × 39cm)
- DMC six-stranded thread:
 dark cherry 3802
 vermilion 349
 watermelon 3705
 forest green 701
 sap green 906
 tea green 16
 sugar pink 894
 poppy 606
 black 310
 primrose 307
 cornflower blue 340
 white B5200
- Embroidery hoop
- Crewel (embroidery) needle
- Ballpoint pen or erasable marker
- 12in (30cm) zip
- Sewing thread to match fabric
- Bobble braid, 63in (1.6m) long
- Cushion pad, 14in (35cm) square

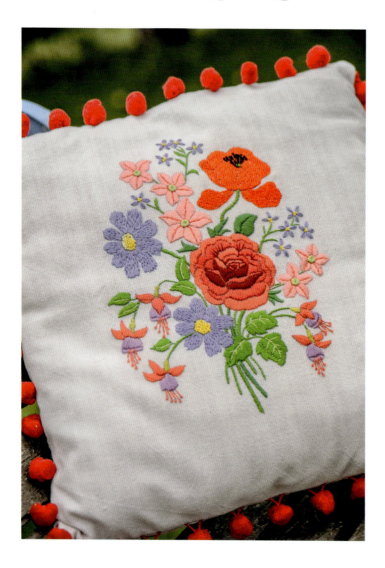

STITCHES USED

- backstitch (p. 16)
- chain stitch (p. 18)
- French knot (p. 18)
- long and short stitch (p. 19)
- satin stitch (p. 19)
- split stitch (p. 20)
- stem stitch (p. 20)
- straight stitch (p. 20)

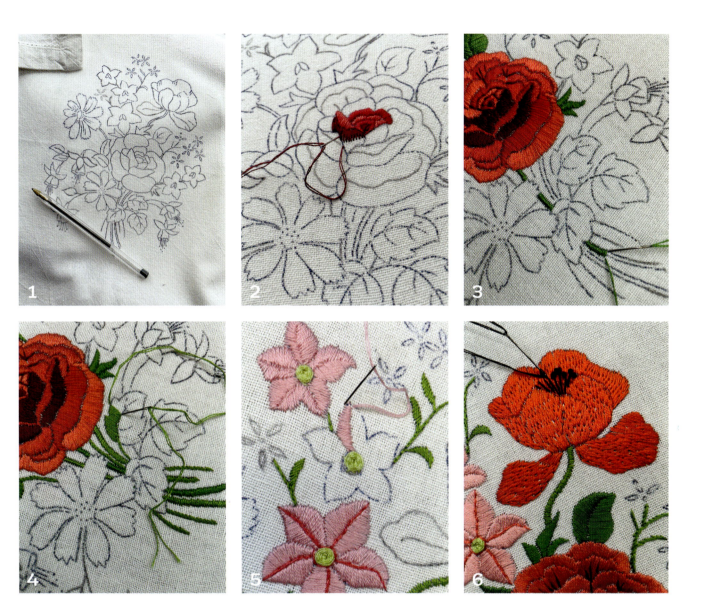

EMBROIDERING THE MOTIF

Use two strands of thread throughout

1. Trace or transfer the summer bouquet motif from page 69 onto the centre of the fabric. The marks can be permanent, as they will be completely covered by the embroidery. Place the fabric in an embroidery hoop. A 10in (25cm) hoop will accommodate the whole design, but you may prefer to work with a smaller hoop and move it to work on smaller areas at a time.

2. Using the three shades of red – dark cherry 3802, vermilion 349 and watermelon 3705 – fill in the shapes that make up the rose using satin stitch, working from the centre outwards and using the photograph of the finished cushion, opposite, as a guide to colour placement.

3. Using forest green 701 and satin stitch, fill in the leaf shapes around the rose and the main rose stem.

4. Using sap green 906, embroider the other stems in stem stitch. With the same colour, fill in the other leaves, using satin stitch and, for larger areas, long and short stitch. Then, using tea green 16, add leaf veins in split stitch.

5. For the star-shaped flowers – nicotiana – fill in the centres with tea green 16, then use sugar pink 894 for the petals, working each petal in two halves with satin stitch. Then add backstitch markings on the petals using watermelon 3705.

6. Fill in the poppy petals in long and short stitch, using poppy 606, then add stamens by working straight stitches topped with French knots in black 310.

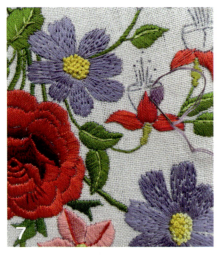

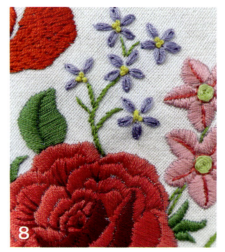

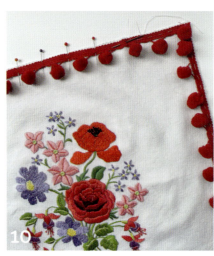

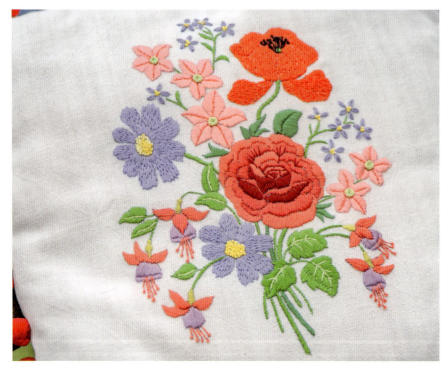

7. For the large Marguerite daisies, fill in each centre with a cluster of French knots in primrose 307, then fill in the petals using long and short stitch in cornflower blue 340, with highlights in white B5200.

8. For the small sprays of flowers, embroider each petal with a single detached chain stitch in cornflower blue 340, then add three French knots in each flower centre using primrose 307. Remove the fabric from the hoop and press on the reverse, if necessary, following the pressing guidelines on page 11.

MAKING THE CUSHION COVER

9. Cut the backing fabric into two pieces, one 14½ × 11⅞in (37 × 30cm) and one 14½ × 3½in (37 × 9cm). Insert the zip between the two long edges. To do this, join the two pieces with a ⅜in (1cm) seam, using running stitch or a long machine stitch. Press the seam open and place the zip on the wrong side, behind the seam; stitch in place, then unpick the seam.

10. Pin, baste and stitch the bobble braid to the right side of the cushion front. Place the backing, with the zip partially opened, face down on top and stitch in place all round, ⅝in (1.5cm) from the edge. Clip corners and turn right sides out.

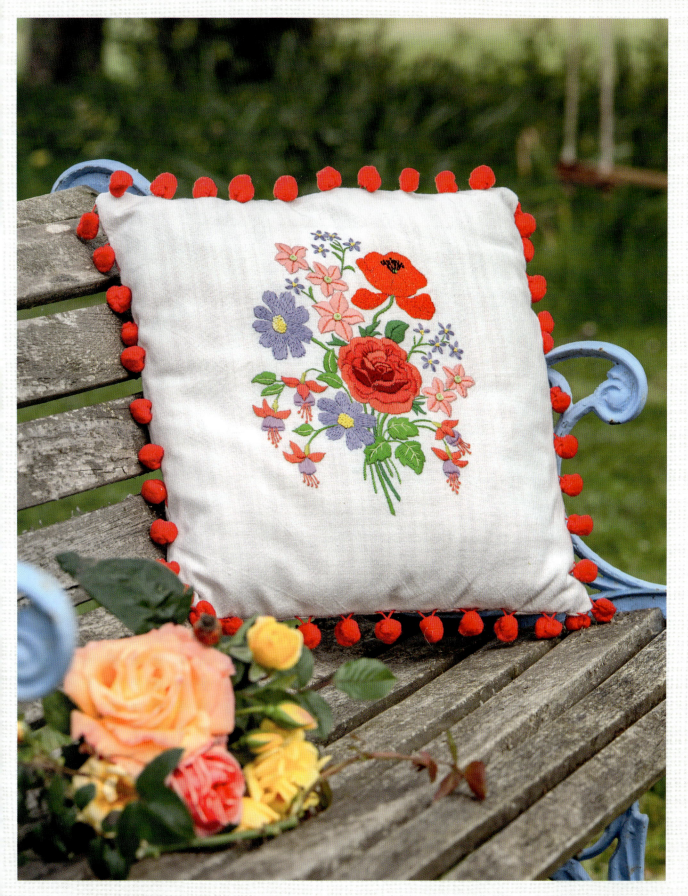

EXOTIC BLOOMS

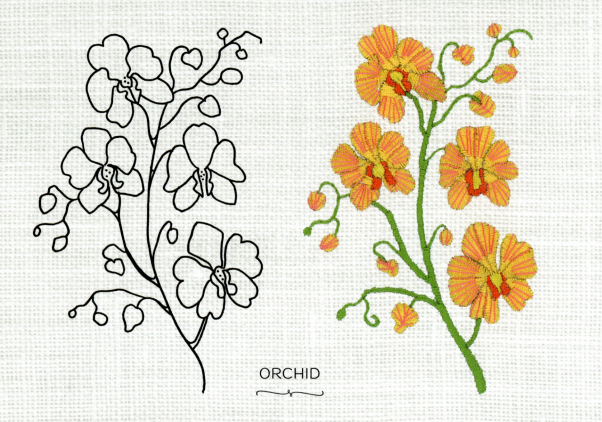

ORCHID

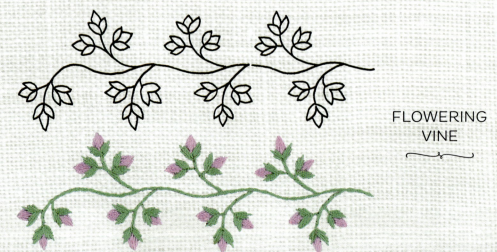

FLOWERING VINE

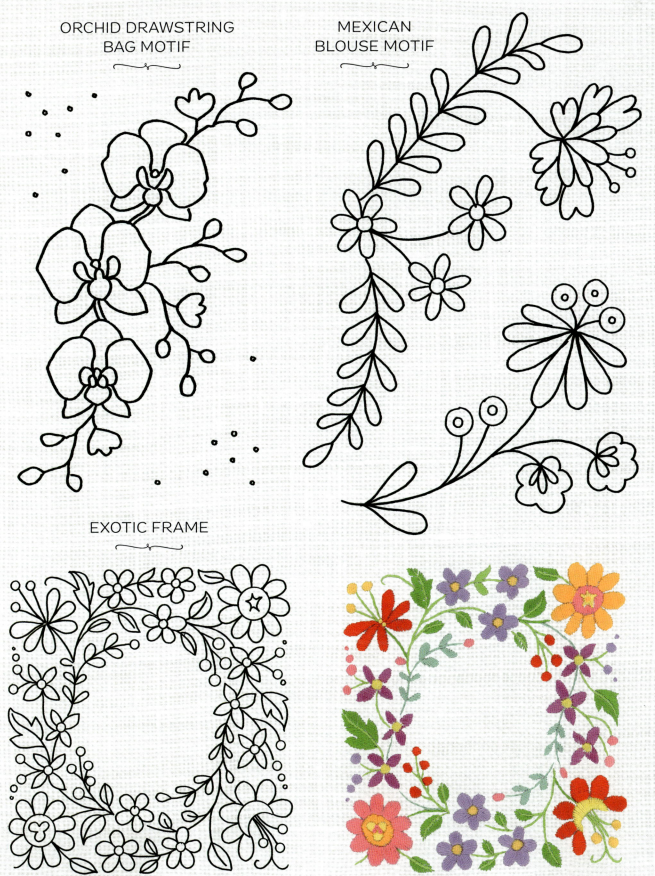

EXOTIC BLOOMS

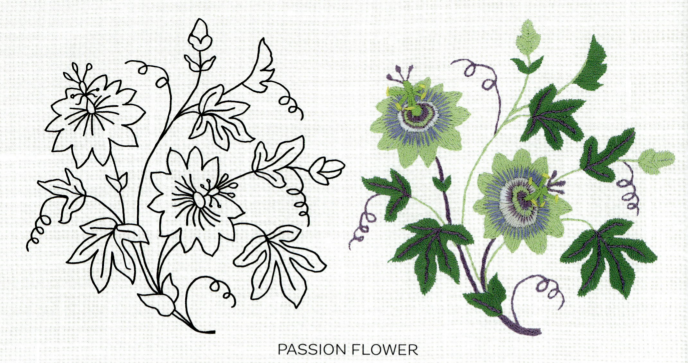

PASSION FLOWER

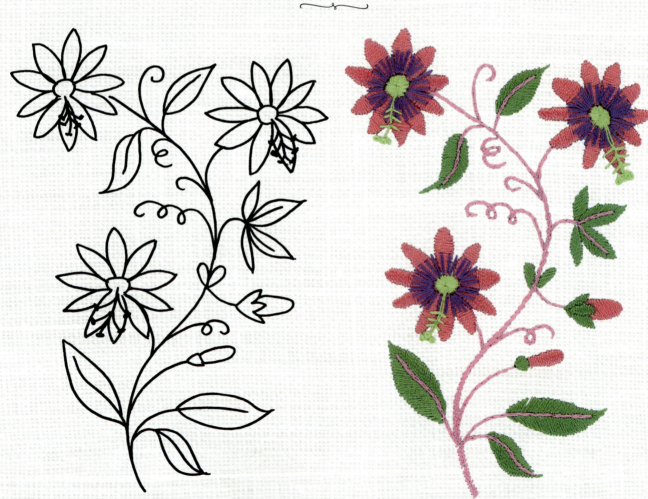

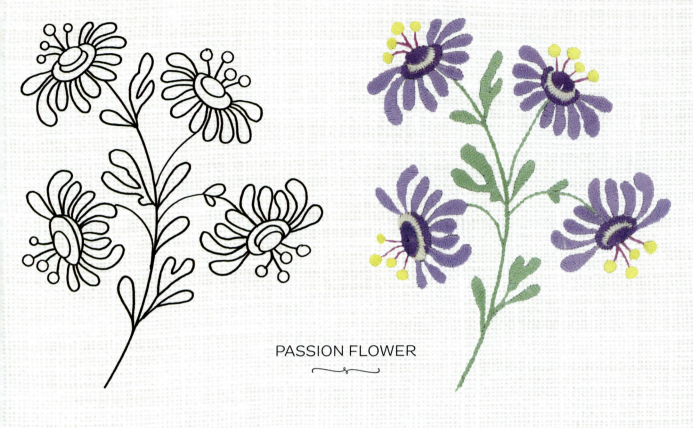

PASSION FLOWER

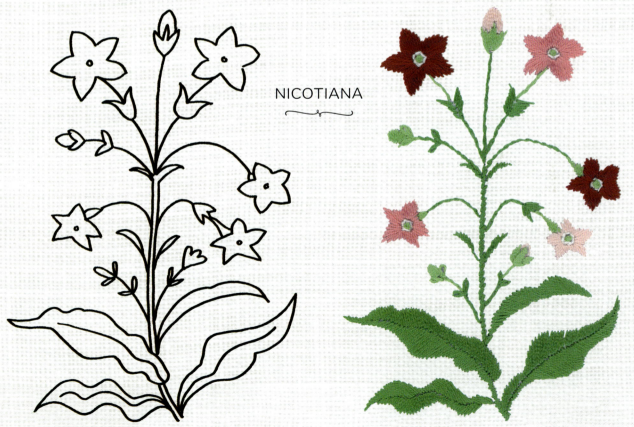

NICOTIANA

EXOTIC BLOOMS

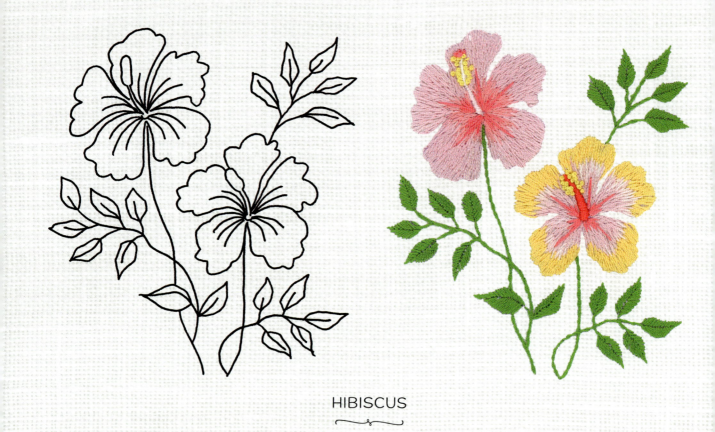

HIBISCUS

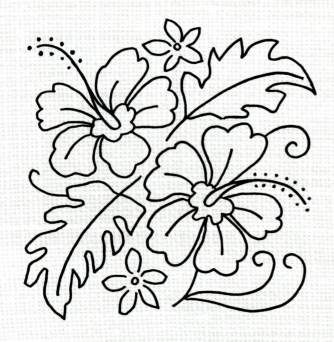
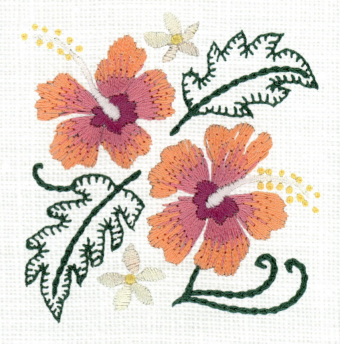

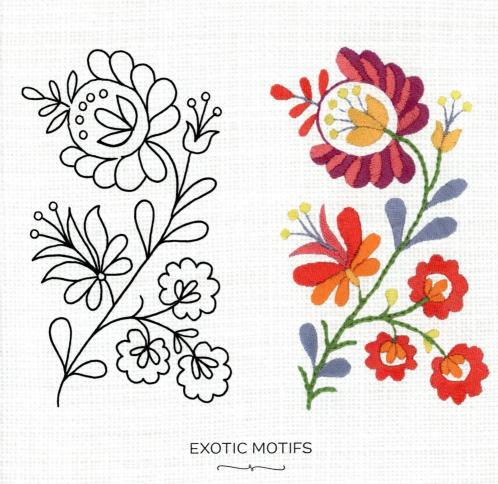
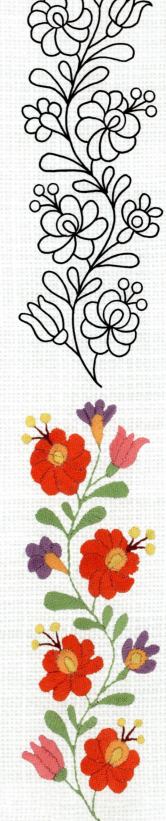

EXOTIC MOTIFS

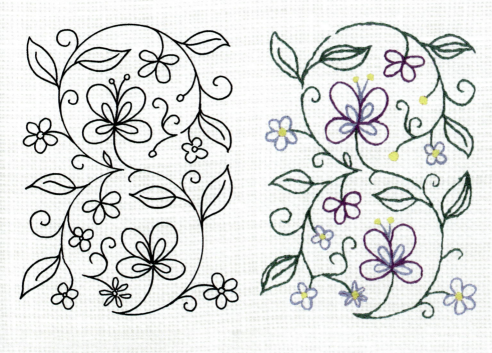

MEXICAN BLOUSE

Inspired by traditional Mexican embroidery, this motif is designed to fit on the yoke of a blouse, or around the neckline, and looks most effective when embroidered with colourful threads. If your shirt or blouse doesn't look like the one in the photograph, the motif can easily be adapted to fit.

YOU WILL NEED

- Cotton shirt or blouse
- DMC six-stranded thread:
 fern green 703
 forget-me-not-blue 794
 poppy 606
 orange 740
 amethyst 553
 bubblegum 956
 sunshine yellow 444
- Embroidery hoop
- Crewel (embroidery) needle
- Permanent or erasable marker

STITCHES USED

- chain stitch (p. 18)
- French knot (p. 18)
- satin stitch (p. 19)
- split stitch (p. 20)

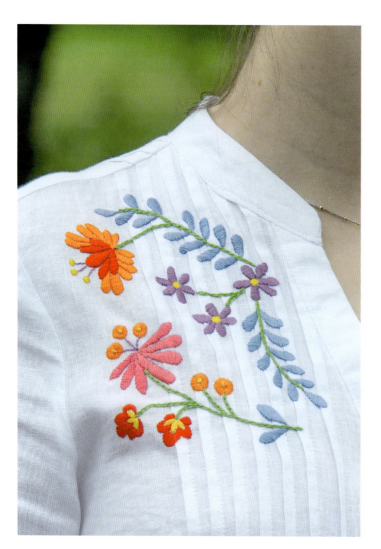

TIP

The motif can be used on a variety of different garments. Here it has been added to a shirt, either side of the front button fastening. It would look equally good on the bodice of a plain dress and could easily be adapted to a child's dress. This shirt has pintucks, creating a textured surface, but this is not an obstacle to adding embroidery: you do not need to start with smooth fabric.

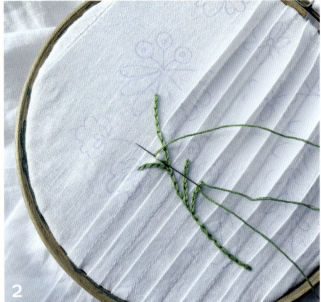
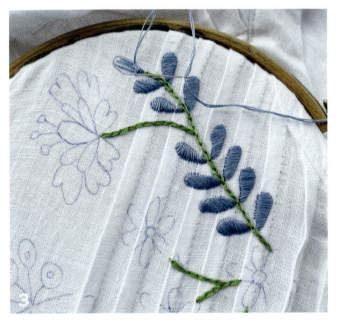
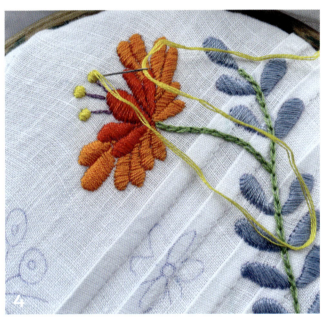

EMBROIDERING THE MOTIF

Use two strands of thread throughout

1. Trace or transfer the Mexican blouse motif from page 81 on to the left-hand side of the shirt, reversing it for the right-hand side. You can use a ballpoint pen, as all the lines should be covered by embroidery stitches, or an erasable marker if you prefer. Position the design high on the yoke, above the bustline. Select your colours and place the fabric in an embroidery hoop. You will need a small hoop that can be moved from place to place to work on different areas of the design.

2. Work the stems in chain stitch, using fern green 703.

3. Fill in the leaf shapes with satin stitch using forget-me-not blue 794. Start by working a few stitches down the length of the shape before working the satin stitches close together across the shape; this will help to ensure good coverage.

4. Use poppy 606 and orange 740 for the petals of the top flower. Work the stamens in split stitch using two strands of amethyst 553, with the anthers in satin stitch using sunshine yellow 444.

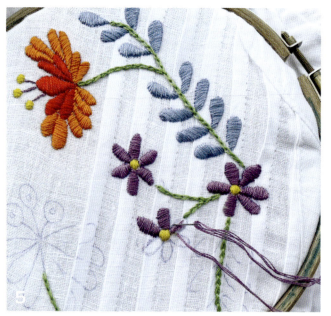
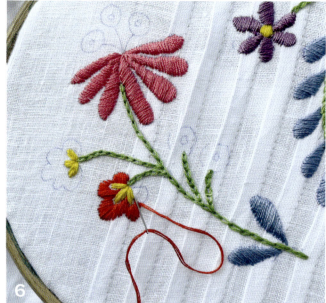
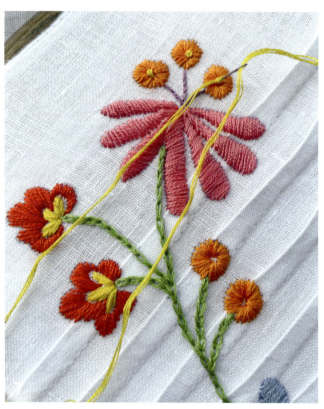
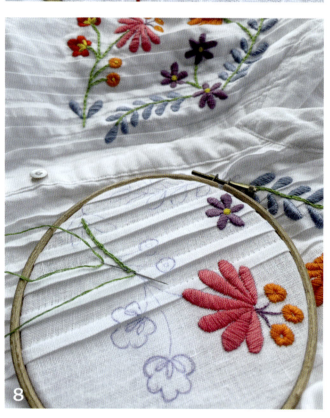

5. Still using sunshine yellow 444, fill in the flower centres of the three smaller flowers, then use amethyst 553 for the petals.

6. For the remaining large flower, fill in the petals using satin stitch and bubblegum 956. For the two smaller flowers, fill in the centres in sunshine yellow 444 then complete the petals using poppy 606.

7. Using orange 740, fill in the circles in satin stitch, leaving a small gap in the centre. Finally, work a French knot in the centre of each, using sunshine yellow 444.

8. Work the two sides of the blouse to match.

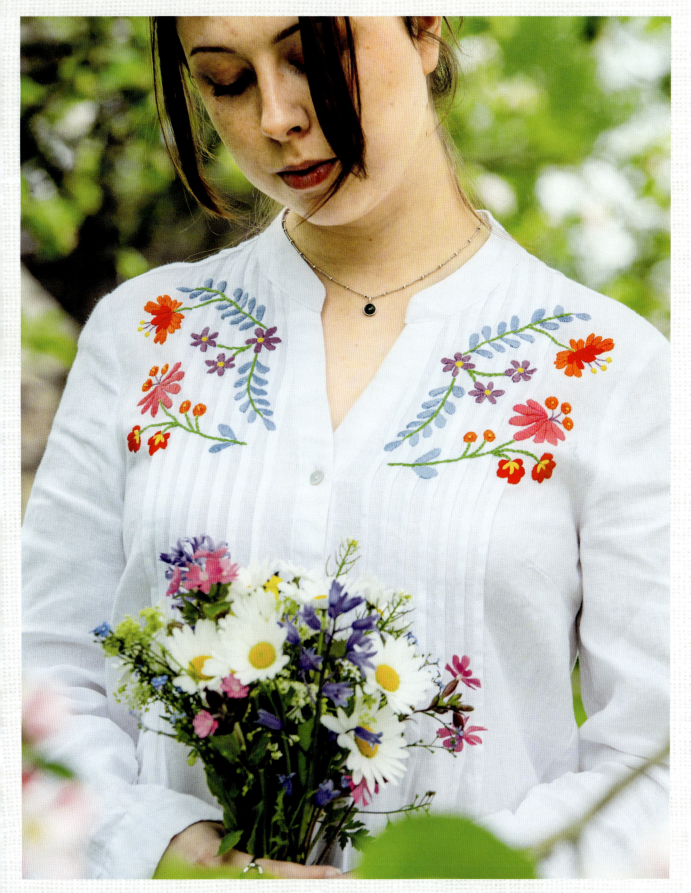

ORCHID DRAWSTRING BAG

A small cloth bag like this one is useful for storing little items such as delicate underwear, jewellery or other treasures. But don't hide it away in a drawer: with its beautiful orchid decoration, it deserves to be on display.

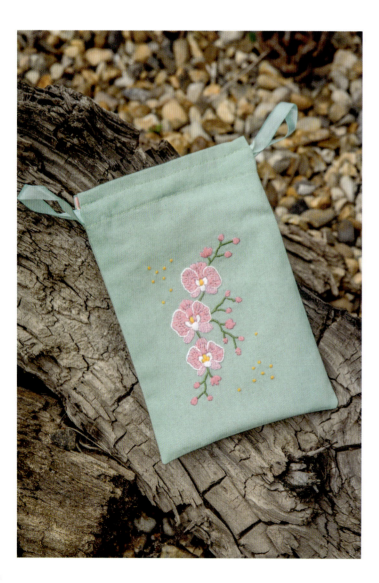

YOU WILL NEED

- Cotton or linen fabric, at least 12½ × 8¾in (32 × 22cm)
- Cotton fabric, plain or printed, for lining, at least 11¾ × 8¼in (30 × 21cm)
- DMC six-stranded thread:
 moss green 988
 apricot 742
 white B5200
 orchid pink 3609
 deep rose 3806
- Embroidery hoop, 7in (18cm) diameter
- Crewel (embroidery) needle
- Permanent or erasable marker
- Narrow ribbon, 33in (84cm) length

STITCHES USED

- French knot (p. 18)
- long and short stitch (p. 19)
- overcast stitch (p. 19)
- satin stitch (p. 19)
- split stitch (p. 20)
- split stitch filling (p. 20)

CREATIVE IDEAS

This is a very versatile project: you could make a larger or smaller bag and use different motifs to decorate it. It would make a lovely little token for a bridesmaid or you could use it as a gift bag for a special person.

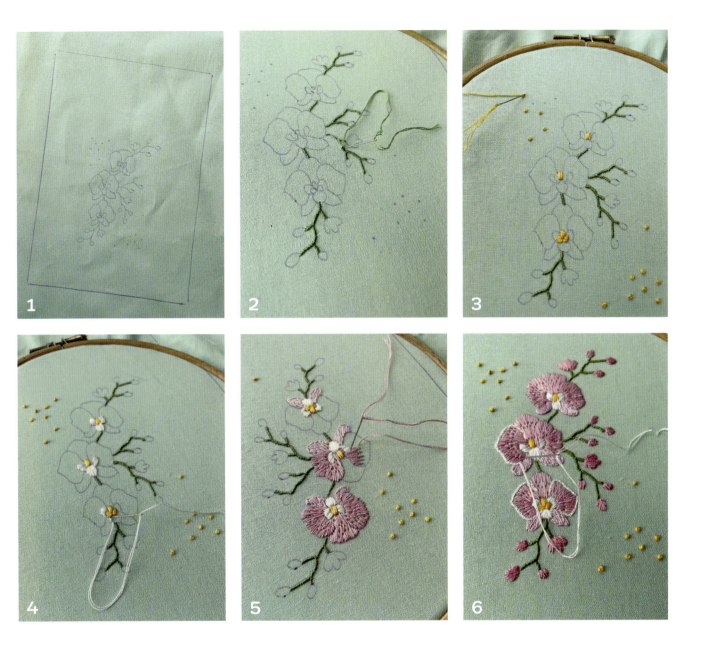

EMBROIDERING THE MOTIF

Use two strands of thread throughout

1. Mark out a rectangle 8¼ × 6in (21 × 15cm) on one half of the main fabric. You could use a ballpoint pen or an erasable marker for the motif, but use a permanent marker for the outline of the bag. Trace or transfer the orchid bag motif from page 81, placing it in the centre of the marked rectangle.

2. Select your colours and place the fabric in an embroidery hoop. Work the stems in overcast stitch, using two strands of moss green 988.

3. Using apricot 742, fill in each flower centre with satin stitch. With the same colour, work a French knot on each marked dot.

4. Using white B5200, fill in the small shapes around the centres in satin stitch.

5. Fill in the two lower petals with split stitch filling, using two strands of orchid pink 3609; for the other petals, thread your needle with one strand of orchid pink 3609 and one strand of deep rose 3806 and embroider using long and short stitch.

6. For the buds, use deep rose 3806 and satin stitch. Lastly, using white B5200, outline the two side petals on each flower, using split stitch. Remove the work from the hoop and press.

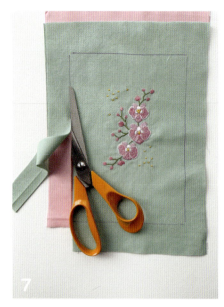
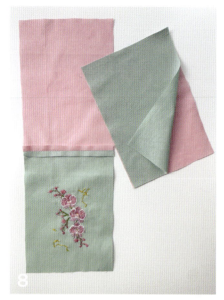
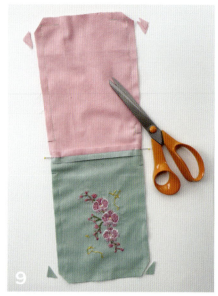
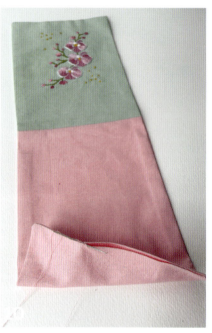
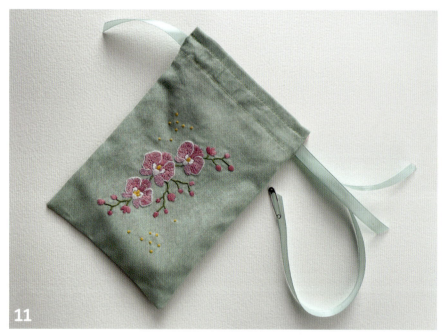

MAKING THE BAG

7. Cut out the rectangle you marked in step 1, then cut a further rectangle from the main fabric and two from the lining fabric the same size.

8. Join one lining piece to the short edge at the top of the embroidered piece – the front of the bag – and the other to the back of the bag.

9. Press the seams open and place the two pieces right sides together, lining up the edges and the seams. Pin together. Measure and make a mark 1in (2.5cm) either side of the seam. Stitch the bag all round with a ⅝in (1cm) seam allowance, leaving the edges between the marked points unstitched and also leaving a gap in the short edge of the lining, for turning. Clip the corners.

10. Turn right sides out through the gap in the lining, tuck the raw edges inside and press, then slipstitch the opening closed.

11. On the top of both the front and back of the bag, topstitch ⅞in (2.2cm) and again ⁵⁄₁₆in (8mm) from the top edge, to create a channel. Cut the ribbon into two equal lengths and thread these through the channel, knotting the ends together, to form drawstrings.

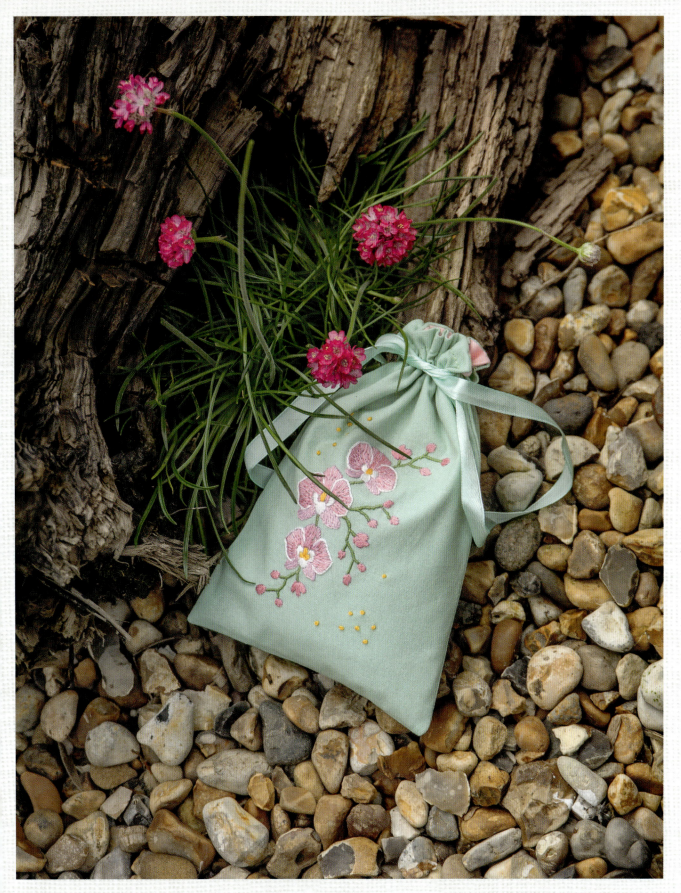

SUNNY MEADOW

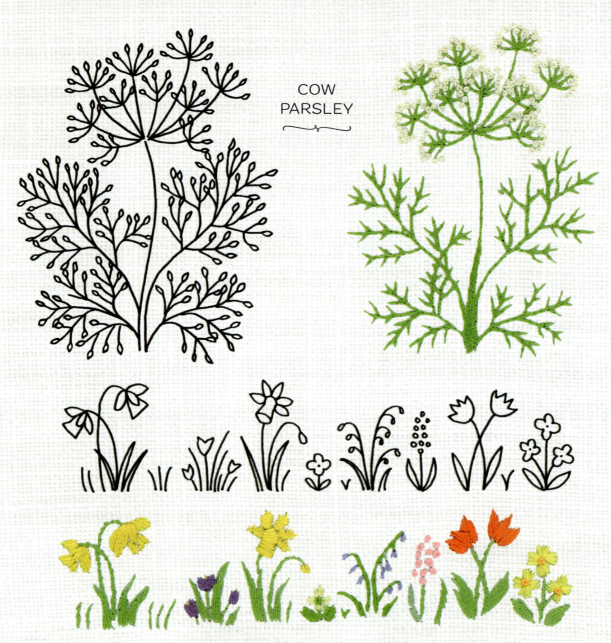

COW PARSLEY

FLOWER AND GRASS BORDER

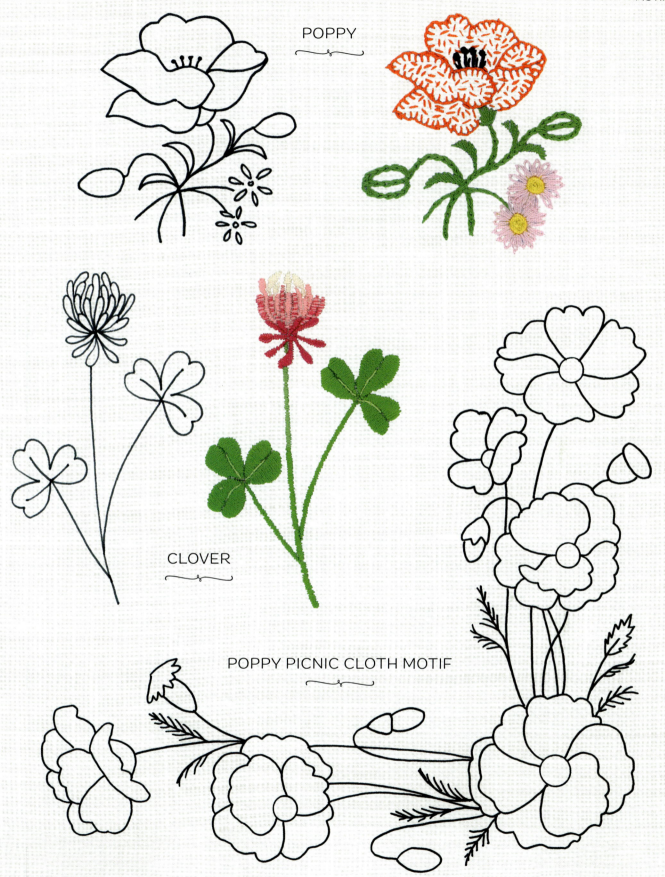

SUNNY MEADOW

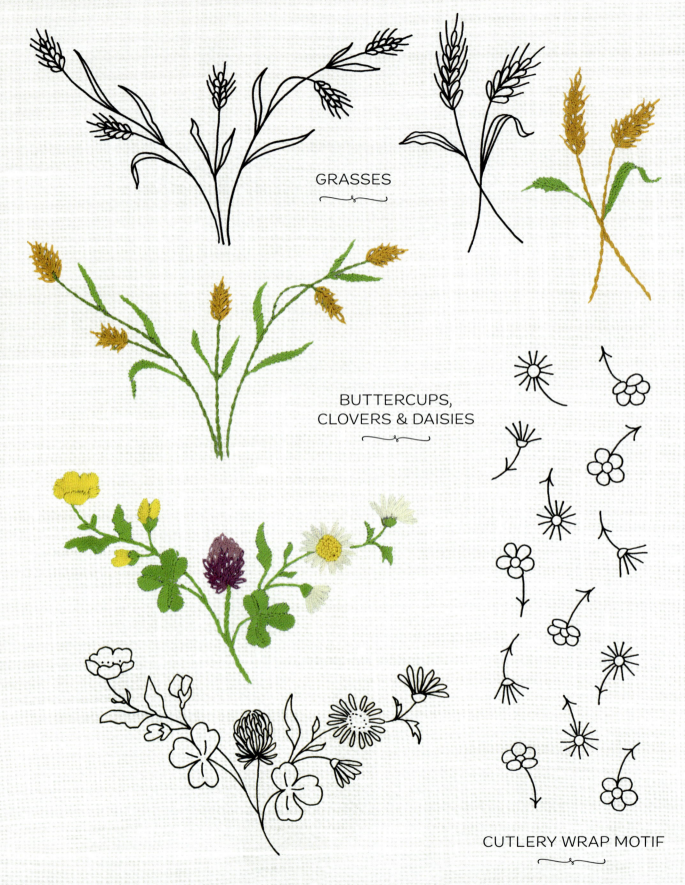

POPPY PICNIC CLOTH

An embroidered cloth can be used to lay the table – but in summer, the season for outdoor eating, why not use it for a picnic? It makes dining al fresco a memorable occasion. Choose a small tablecloth or make your own from crisp white cotton or linen.

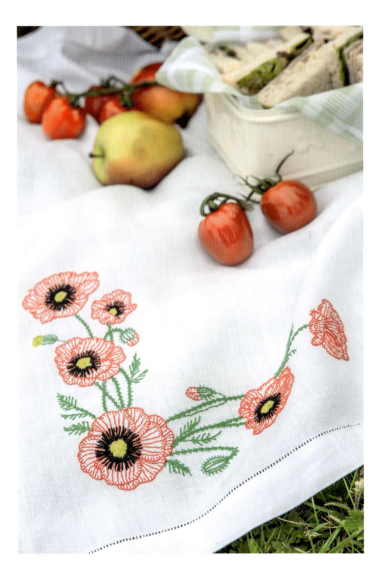

YOU WILL NEED

- Cotton or linen tablecloth, 24in (60cm) square
- Backing fabric, 14½ × 15⅜in (37 × 39cm)
- DMC six-stranded thread:
 vermilion 349
 forest green 701
 olive green 166
 black 310
- Embroidery hoop
- Crewel (embroidery) needle
- Erasable marker

STITCHES USED

- backstitch (p. 16)
- blanket stitch (p. 17)
- French knot (p. 18)
- satin stitch (p. 19)
- straight stitch (p. 20)

TIP

Whether you choose a brand-new tablecloth or an antique one, a size of 24in (60cm) square or thereabouts is ideal. If you are making your own, you will need a piece of fabric slightly larger than this, to allow for a double hem all round.

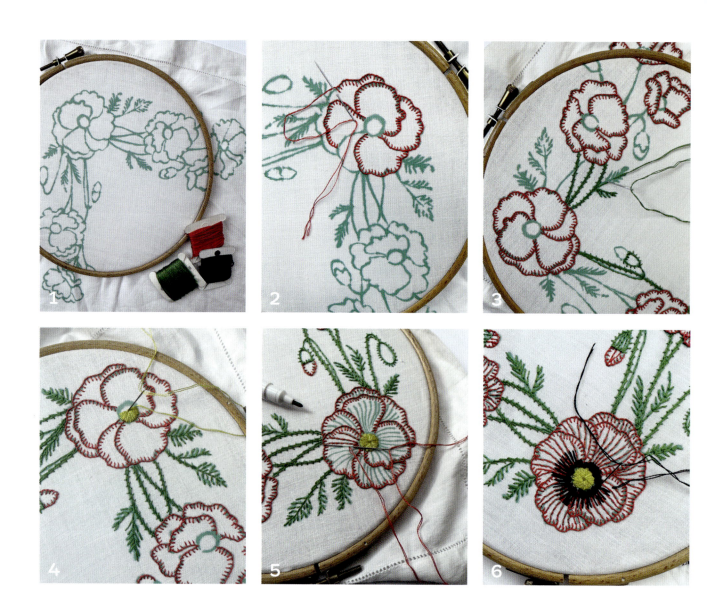

EMBROIDERING THE MOTIF

Use two strands of thread throughout

1. Trace or transfer the poppy motif from page 95, positioning it on one corner of the tablecloth. The marks should be erasable, as they will not be completely covered by the embroidery.

2. Place the fabric in an embroidery hoop. Embroider the outline of each petal in blanket stitch, using vermilion 349, with the 'legs' of the stitches facing inwards and the tops of the stitches forming the outlines.

3. Embroider the stems using forest green 701, again using blanket stitch but this time working two rows of stitches, back to back, with the legs of the stitches facing outwards to suggest the hairy stems of the poppies. Embroider the fern-like leaves in backstitch.

4. Fill in the flower centres in satin stitch, using olive green 166, with each straight stitch radiating out from the central point.

5. With the erasable pen, draw guidelines on each petal, from the flower centre outwards, and stitch along each of these lines in backstitch using vermilion 349. Do the same with the seed pods and flower buds, this time using forest green 701.

6. Surround the flower centres with French knots, using black 310, then add straight stitches radiating out from the centre to suggest stamens.

Remove the fabric from the hoop and rinse in lukewarm water to remove the drawn lines. When dry, press on the reverse, following the pressing guidelines on page 11.

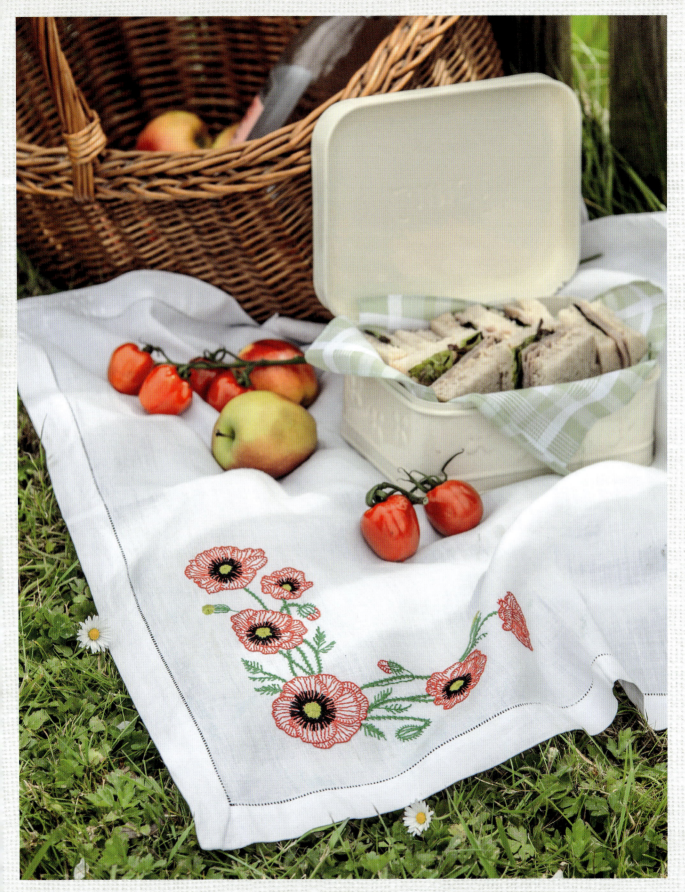

BUTTERCUPS AND DAISIES CUTLERY WRAP

With your own set of cutlery, neatly wrapped, you are ready to enjoy a packed lunch or picnic at a moment's notice. The flowers are quick and easy to embroider and the construction of the wrap is simplicity itself. Make several sets, one for each member of the family, filling them with a useful collection of eating implements, such as knife, fork, spoon, chopsticks and reusable straw.

YOU WILL NEED
- Cotton, medium-weight, 13¾ × 8½in (35 × 21.5cm)
- Lining fabric, 13¾ × 8½in (35 × 21.5cm)
- DMC six-stranded thread:
 sunshine yellow 444
 fern green 703
 B5200 white
- Embroidery hoop
- Crewel (embroidery) needle
- Erasable marker
- Elastic, 3in (7.5cm) length × ¼in (6mm) wide
- Bias binding, 16½in (42cm) × ⅝in (1.5cm) wide
- Sewing thread to match binding
- Button

STITCHES USED
- chain stitch (p. 18)
- French knot (p. 18)
- satin stitch (p. 19)
- stem stitch (p. 20)

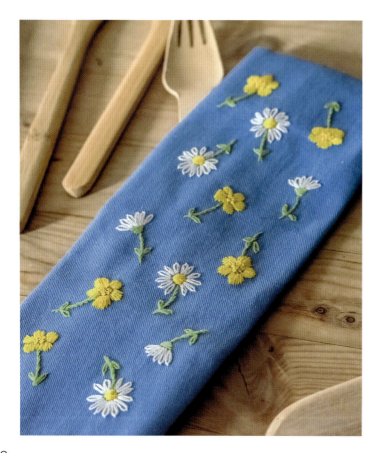

 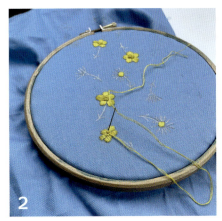 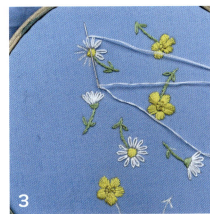
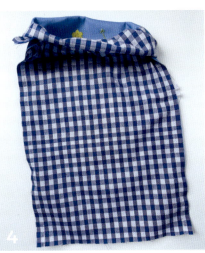 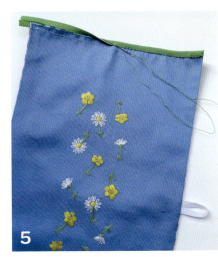 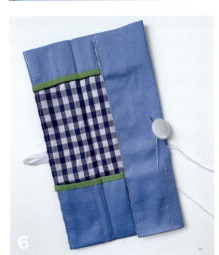

EMBROIDERING THE MOTIF

Use two strands of thread throughout

1. Trace or transfer the cutlery wrap motif from page 96 positioning it centrally, with the top of the design approximately 2¾in (6cm) from the top edge of the fabric. The marks should be erasable, as they may not be completely covered by the embroidery – a white chalk pencil is ideal for this.

2. Place the fabric in an embroidery hoop. Using sunshine yellow 444, fill in each buttercup petal and each daisy centre in satin stitch. Using the same colour, fill the centre of each buttercup with French knots.

3. Embroider the stems using fern green 703, using stem stitch. Using the same colour, embroider each of the small leaves with a single detached chain stitch. Change to B5200 white and embroider the daisy petals using detached chain.

Remove the fabric from the hoop and erase the drawn lines. Press the work on the reverse, following the pressing guidelines on page 11.

MAKING THE WRAP

4. Place the embroidered fabric and lining fabric right sides together. Fold the piece of elastic in half and sandwich it between the fabric pieces, on the right-hand side, approximately 6¼in (16cm) from the top. Stitch the two long sides with a ⅜in (1cm) seam. Turn right sides out and press.

5. Cut the bias binding into two equal lengths and use it to bind the two short edges, top and bottom. Fold the bottom edge to the inside to form a pocket 3⅛in (8cm) deep; do the same at the top to form a flap 1½in (4cm) deep. Topstitch down the long sides, close to the edge, through all thicknesses. Then stitch two vertical lines through the pocket, 1½in (4cm) from each side, to create dividers.

6. Fold in 2¼in (5.5cm) on each side towards the centre; sew a button on the outside of the wrap to correspond with the elastic loop.

HERBACEOUS BORDER

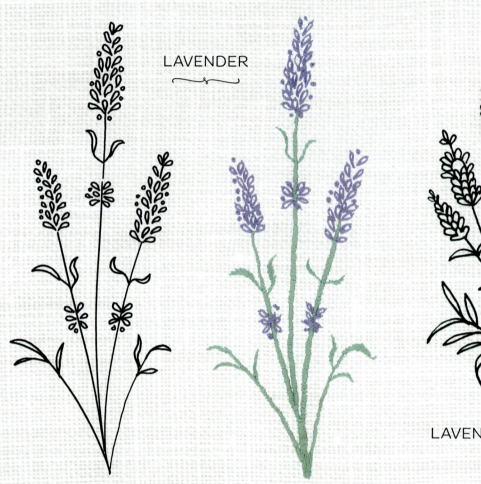

LAVENDER

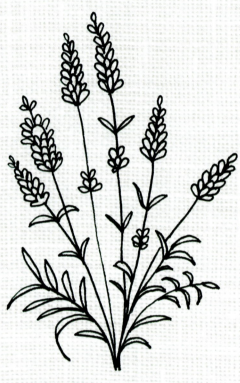

LAVENDER SACHET MOTIF

ASTER TOWEL BORDER MOTIF

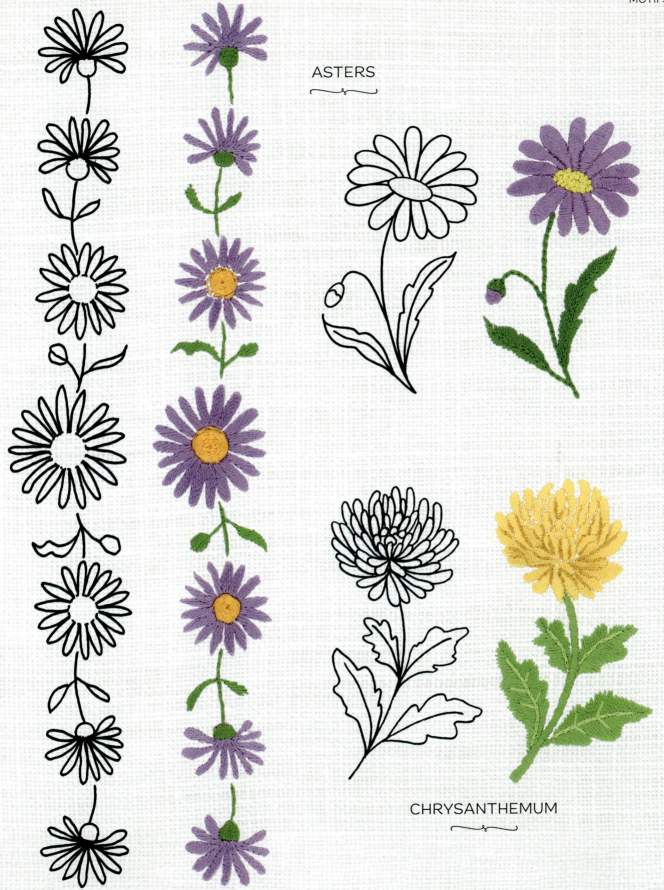

ASTERS

CHRYSANTHEMUM

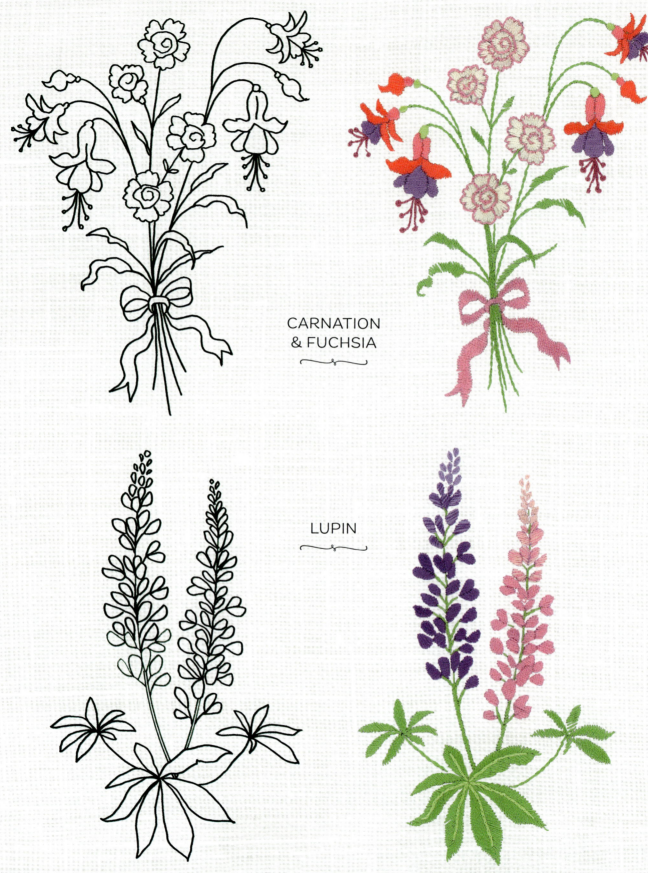

CARNATION & FUCHSIA

LUPIN

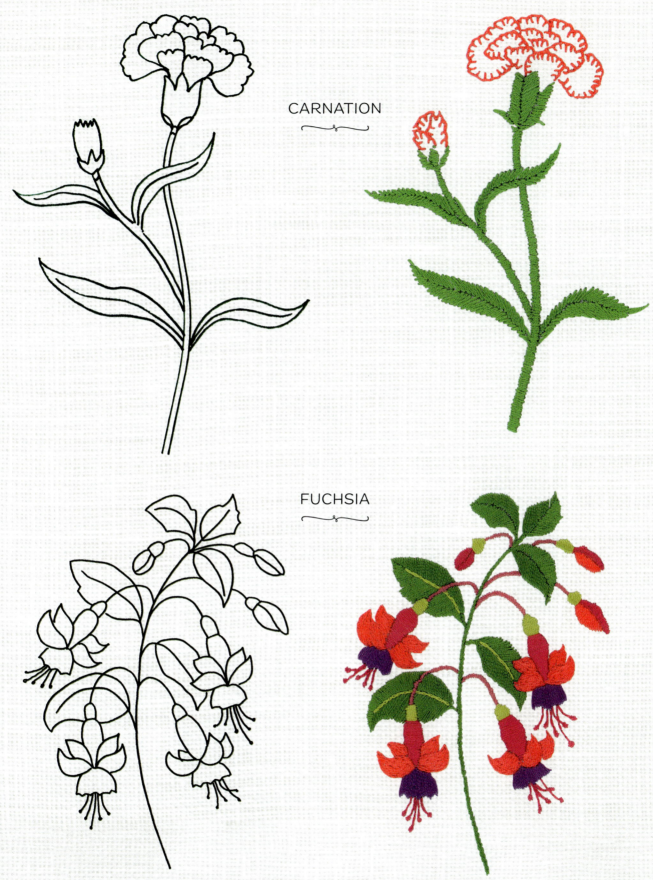

CARNATION

FUCHSIA

HERBACEOUS BORDER

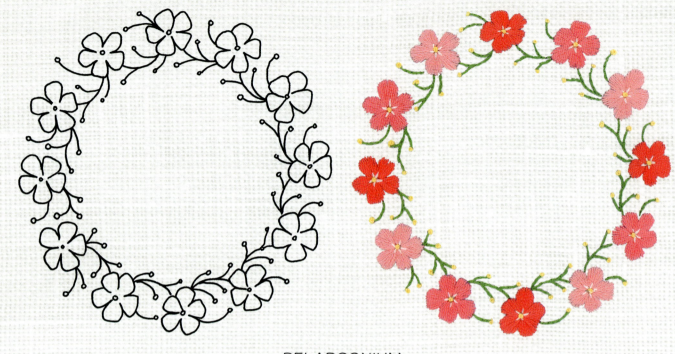

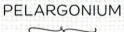

PELARGONIUM

LAVENDER SACHET

This fragrant little pillow is practical as well as pretty: kept in a drawer, it will not only scent your clothing, it will also help to deter moths. The embroidery is relatively quick to do, so you could make a number of these, some to keep and others to give away.

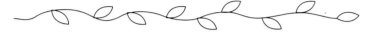

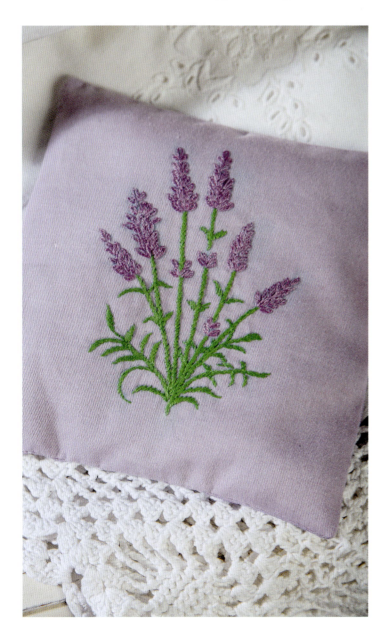

YOU WILL NEED

- Cotton or linen fabric, two pieces each approximately 6in (15cm) square
- DMC six-stranded thread:
 emerald green 702
 amethyst 553
- Embroidery hoop, 4½in (11cm) diameter
- Crewel (embroidery) needle
- Erasable marker
- Dried lavender
- Sewing thread to match fabric

STITCHES USED

- detached chain stitch (p. 18)
- stem stitch (p. 20)

TIP

You can enhance the smell of the dried lavender by adding one or two drops of lavender essential oil.

CREATIVE IDEAS

This is a simple design and relatively quick to stitch, so it is a good choice for when you are making multiple items, such as a set of napkins or towels, or a batch of greetings cards (like the snowdrops on page 128). Or could use it on the yoke of a nightdress, then repeat it along the hem.

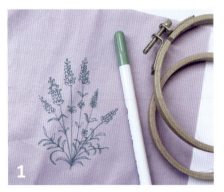 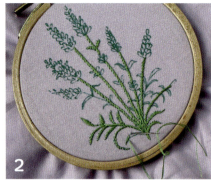 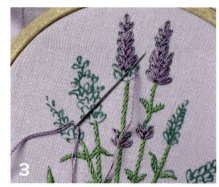
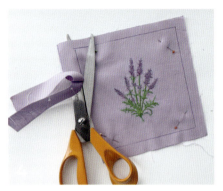 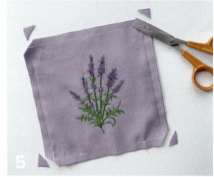 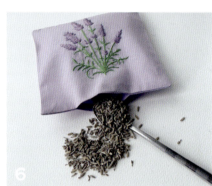

EMBROIDERING THE MOTIF

Use two strands of thread throughout

1. Trace the lavender bag motif from page 102 on to the fabric, positioning it in the centre. Place the fabric in an embroidery hoop.

2. Using emerald green 702, embroider the stems and leaves in stem stitch.

3. Using amethyst 553, embroider the flowers in detached chain stitch. Remove the fabric from the hoop and rinse in tepid water to remove the drawn marks; leave to dry, then press.

MAKING THE SACHET

4. Measure and mark out a 5in (12.5cm) square with the embroidered motif in the centre. Pin the embroidered fabric to a second piece of fabric and cut out both layers along the marked lines.

5. With right sides together and edges aligned, join the two pieces by stitching all round, ⅜in (1cm) from the edge, leaving a 2in (5cm) gap on one edge, for turning. Clip the corners.

6. Turn right sides out and press. Fill with dried lavender; do not overfill.

7. Using matching sewing thread, slipstitch the opening closed.

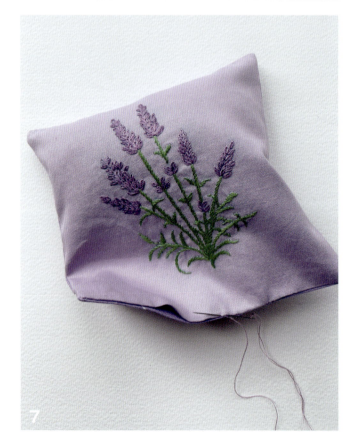

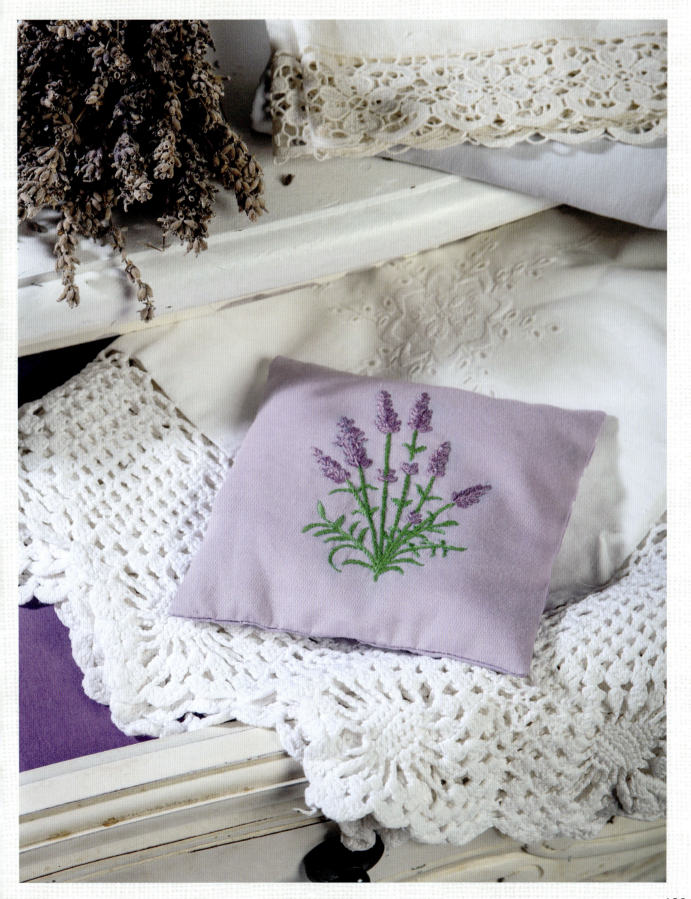

ASTER TOWEL BORDER

Simplified Michaelmas daisies – in reality they have more petals – adorn a little towel. Make one for a house guest or a whole batch of personalized towels for members of your family.

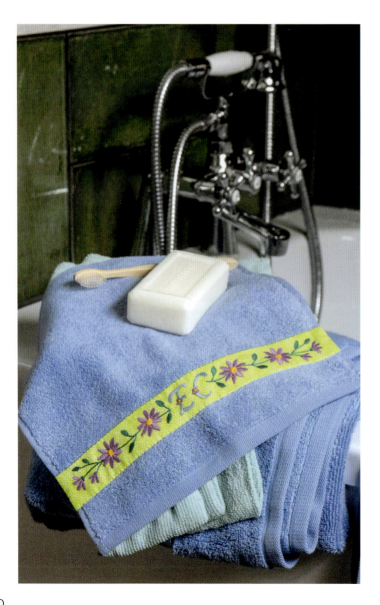

YOU WILL NEED

- Cotton fabric, approximately 15 × 7½in (38 × 19cm)
- DMC six-stranded thread:
 bottle green 991
 apricot 742
 sunshine yellow 444
 amethyst 553
 forget-me-not blue 794
- Embroidery hoop
- Crewel (embroidery) needle
- Permanent marker
- Guest towel or face cloth, approximately 11½in (29cm) wide

STITCHES USED

- French knot (p. 18)
- satin stitch (p. 19)
- stem stitch (p. 20)

TIPS

- You can easily adapt this design to a towel of any width, repeating the flower border motif as necessary. Match the colour of the thread used for the monogram letters to the towel.

- If you are making one towel border, there will be some fabric wastage, as you have to allow extra fabric to accommodate the embroidery hoop. When making two or more, you can mark out the strips with no space in between.

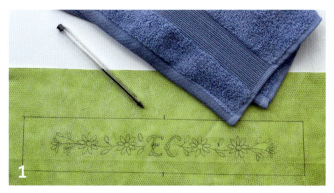
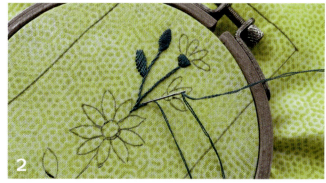
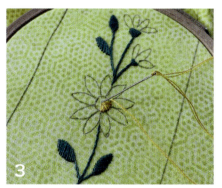
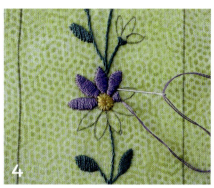
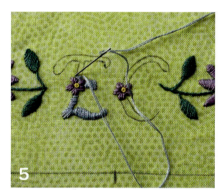
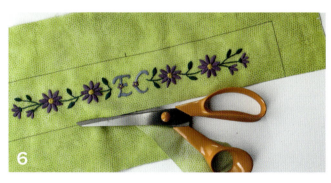
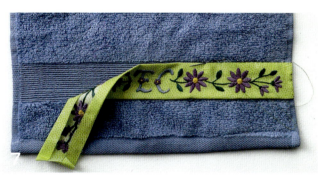

EMBROIDERING THE MOTIF

Use two strands of thread throughout

1. Mark out a rectangular strip 13½ × 2½in (34.5 × 6.5cm) on the fabric, using a permanent marker such as a ballpoint pen. Mark the centre point and mark out your chosen initials – one on either side of the centre – using a decorative font printed at the appropriate size. Then trace the border motif from page 102 on either side of the initials, reversing the motif on one side.

2. Place the fabric in a hoop. Using bottle green 991, stitch the stems in stem stitch and the leaves and bases of the smaller flowers in satin stitch.

3. Thread your needle with one strand of apricot 742 and one strand of sunshine yellow 444 and use this to fill in the flower centres in satin stitch, working the stitches from the perimeter of the circle to a point in the centre.

4. For the petals use amethyst 553 and satin stitch, working the stitches across the petals.

5. For the monogram, fill in the petals of the tiny flowers in satin stitch, using amethyst 553 and add a French knot in the centre of each using sunshine yellow 444. Then fill in the letters in satin stitch using forget-me-not blue 794.

MAKING THE BORDER

6. Remove the fabric from the hoop and press, then cut out along the outline.

7. Fold under ⅜in (1cm) all round and press. Pin the border in place and attach by slipstitching the folded edges to the towel.

WOODLAND WALK

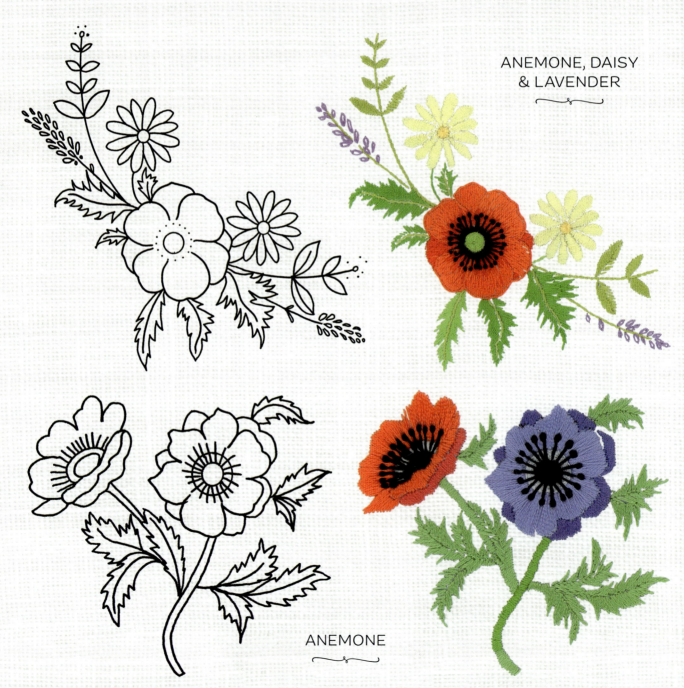

ANEMONE, DAISY & LAVENDER

ANEMONE

MOTIFS

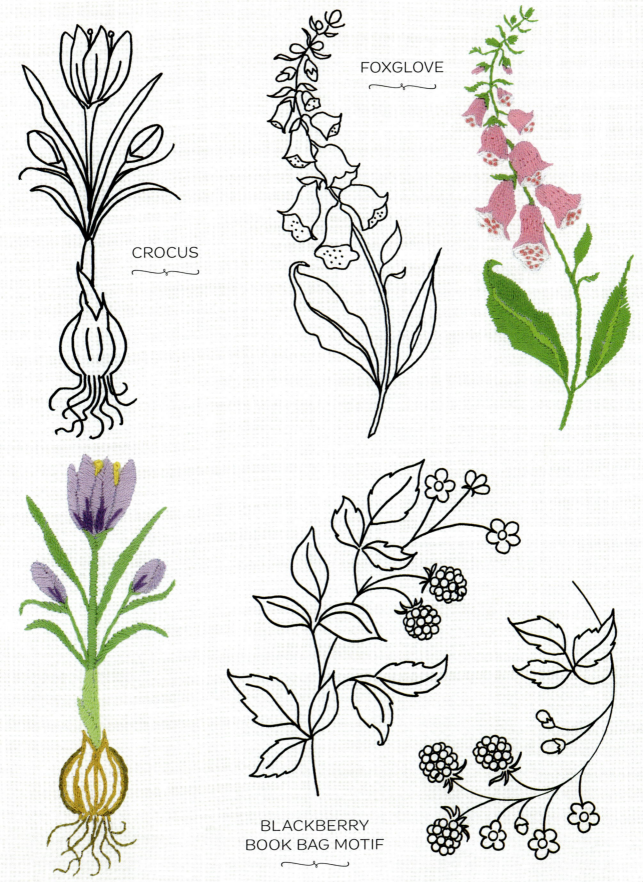

CROCUS

FOXGLOVE

BLACKBERRY
BOOK BAG MOTIF

WOODLAND WALK

FERN

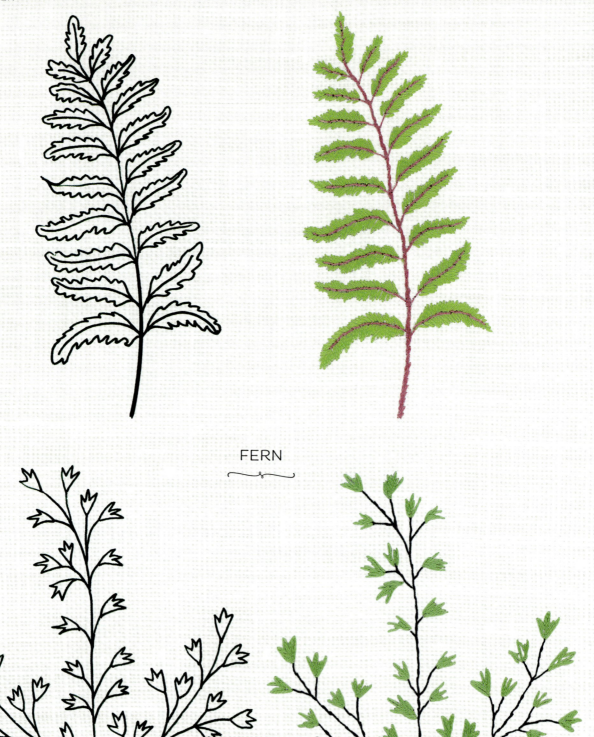

MOTIFS

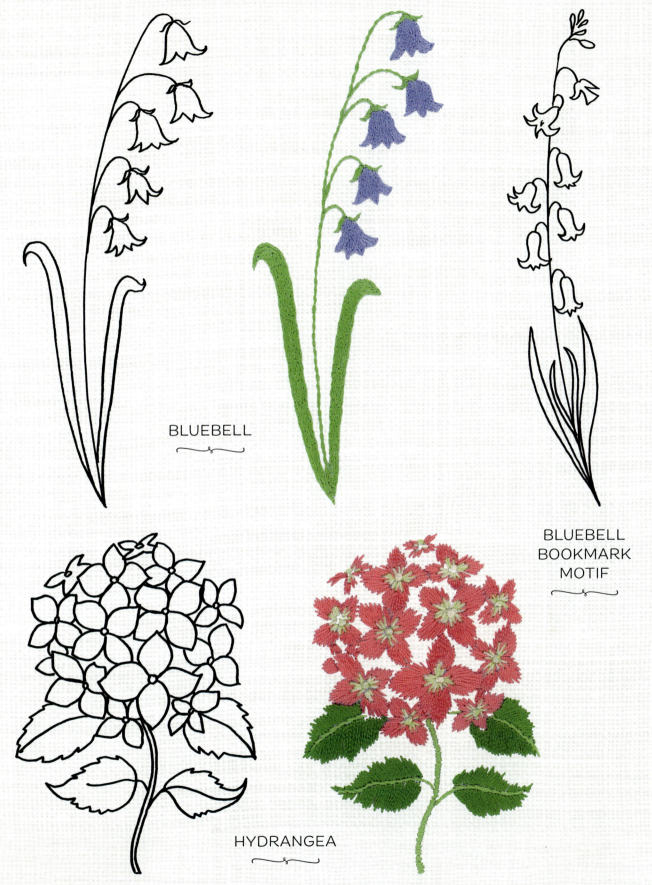

BLUEBELL

BLUEBELL BOOKMARK MOTIF

HYDRANGEA

115

BLUEBELL BOOKMARK

A bookmark helps you to keep your place when reading your favourite book without damaging it by folding over the corner of the page. This one features a delicate bluebell.

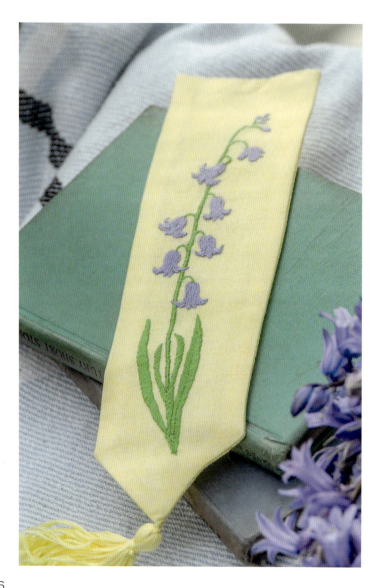

YOU WILL NEED

- Cotton fabric, plain or printed, approximately 11 × 8in (28 × 20cm)
- Cotton fabric, plain or printed, for lining, at least 10 × 6½in (25 × 16cm)
- DMC six-stranded thread:
 emerald green 702
 cornflower blue 340
- Thread to match fabric
- Embroidery hoop
- Crewel (embroidery) needle
- Permanent marker

STITCHES USED

- chain stitch (p. 18)
- overcast stitch (p. 19)
- split stitch (p. 20)

TIP

There are several other motifs scattered throughout the book that could be adapted to fit this project in place of the bluebells, such as the iris (p.45), delphinium (p. 58), exotic flowers (p. 85), lavender (p.102) or the flowering holly (p.126). The fabric colour could be changed accordingly, to contrast with the thread colours used for your chosen flower.

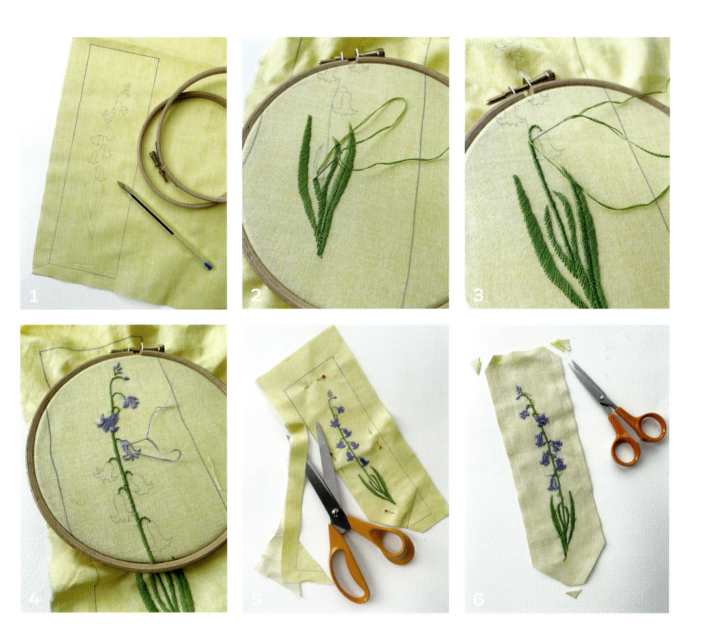

EMBROIDERING THE MOTIF

Use two strands of thread for the embroidery, six strands of thread for the tassel

1. Mark out a rectangle 10 × 3in (25 × 7.5cm) on one half of the fabric, using a permanent marker such as a ballpoint pen. Trace or transfer the bluebell bookmark motif from page 115 on to the centre of the rectangle.
2. Place the fabric in a hoop. Starting with the leaves, using emerald green 702, fill in each leaf shape with satin stitch, slanting the stitches slightly.
3. Using the same thread, embroider the stem in overcast stitch, over a foundation of split stitch.
4. Fill in the flowers using cornflower blue 340 and split stitch. Start by outlining each flower, keeping the stitches short, then fill in with longer stitches. For the tiny buds at the top of the stem, use detached chain stitches. Remove the fabric from the hoop and press.

MAKING THE BOOKMARK

5. Pin two layers of fabric together, right sides together. Measure 1½in (4cm) up from each lower corner and draw lines from these points to the centre of the lower edge to create a sharp point. Cut out the bookmark shape.
6. Stitch all round, with a seam allowance of ¼in (7mm), leaving a gap at the top for turning. Clip corners.

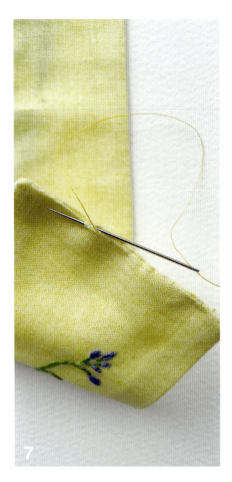
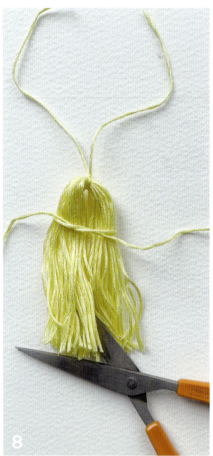
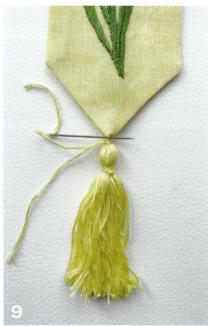
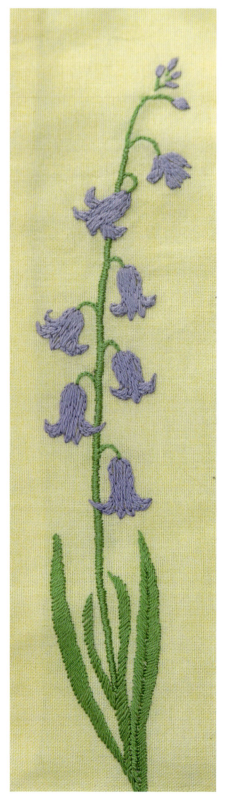

7. Turn right sides out and press. Slipstitch the opening closed.

8. To make a tassel, use a ruler or similar flat object approximately 2¾in (7cm) wide, or cut a piece of sturdy card to this width. Wrap embroidery thread around the object 36 times. Slip an 8in (20cm) length of thread under the bundle of threads. Tie the ends of this thread firmly together, then take a second length of thread and tie it around the bundle to form the head of the tassel. Trim the ends of the tassel.

9. Stitch the tassel securely to the point at the base of the bookmark.

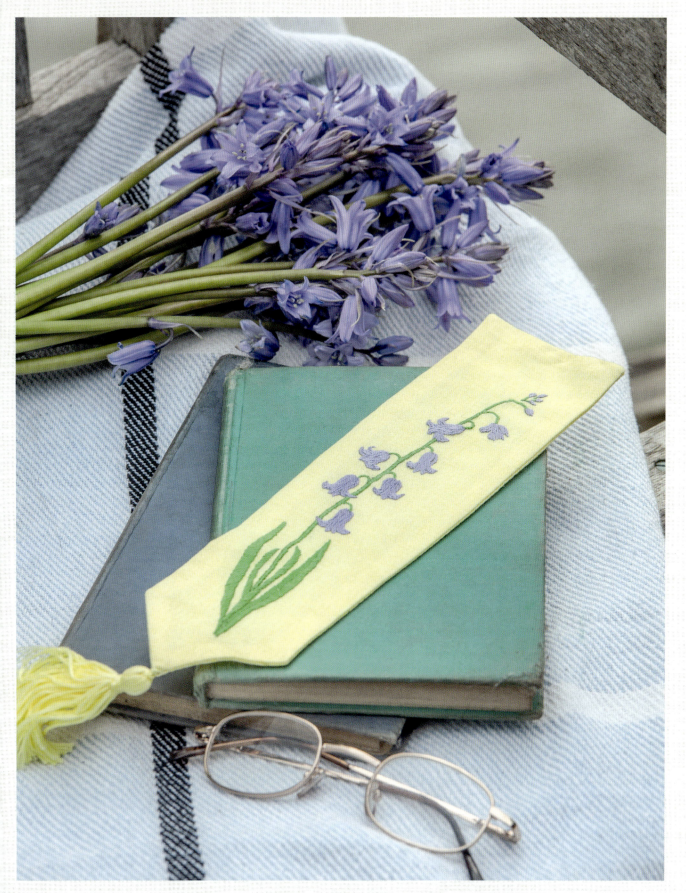

BLACKBERRY BOOK BAG

Just the right size to accommodate your current favourite book, this bag will protect the book, keeping the covers clean. Add initials to the blackberry design, to personalize the bag for you or a friend.

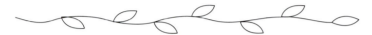

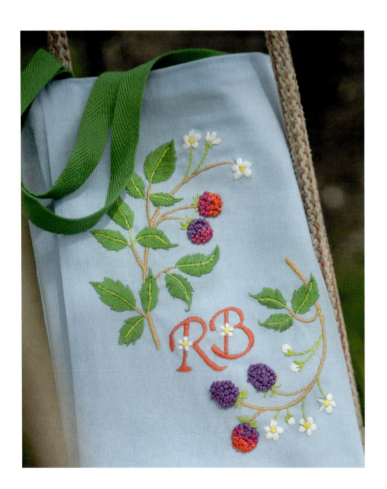

TIP

The bag is sized to fit a novel up to 8½ × 6¼in (22 × 16cm) and 2¼in (6cm) thick.

YOU WILL NEED

- Cotton fabric, approximately 20 × 12in (50 × 30cm)
- Cotton fabric, plain or printed, for lining, at least 18 × 11in (46 × 28cm)
- DMC six-stranded thread:
 café au lait 436
 apple green 907
 forest green 701
 deep purple 3837
 red-violet 718
 vermilion 349
 primrose 307
 white B5200
- Embroidery hoop, 7in (18cm) or 8in (20cm) diameter
- Crewel (embroidery) needle
- Permanent marker
- Cotton herringbone tape, ⅝in (1.5cm) wide and 29½in (75cm) long

STITCHES USED

- backstitch (p. 16)
- running stitch (p. 16)
- French knot (p. 18)
- overcast stitch (p. 19)
- satin stitch (p. 19)
- stem stitch (p. 20)
- straight stitch (p. 20)

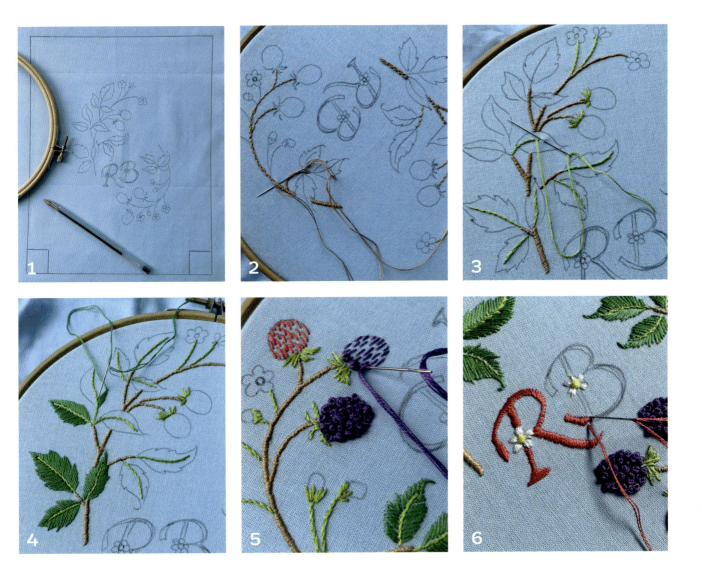

EMBROIDERING THE MOTIF

Use two strands of thread, unless otherwise stated

1. Mark out a rectangle 10⅜ × 8¼in (26.5 × 21cm) on one half of the fabric, using a permanent marker such as a ballpoint pen. On each of the bottom two corners, mark out a small square measuring 1½in (3.5cm). Trace the blackberry motifs from page 113, placing the top one approximately 1¾in (4.5cm) from the top edge and the lower one a similar distance from the bottom edge. Leave a space between the two, where you can mark out your initials using a decorative font printed at the appropriate size.

2. Embroider the main stems in overcast stitch using café au lait 436. For the foundation stitches, use backstitch: one row for thinner stems and two adjacent rows for thicker stems.

3. Use apple green 907 and stem stitch for the very small stems and leaf veins. Use the same shade for the sepals, working a few straight stitches fanning out from the base of each fruit.

4. Fill in the leaf shapes in satin stitch, using forest green 701.

5. For each blackberry, lay a foundation of parallel lines of running stitch, using two strands of either deep purple 3837, red-violet 718 or vermilion 349. Then fill in the shape with French knots, using six strands of thread in the needle. If there are any small gaps, fill these with smaller French knots, using three strands.

6. Fill in the flower centres – including those on the initials – with primrose 307. Fill in the petals with white B5200 and satin stitch. Fill in the letters in vermilion 349, also in satin stitch. When the embroidery is complete, remove the fabric from the hoop and press.

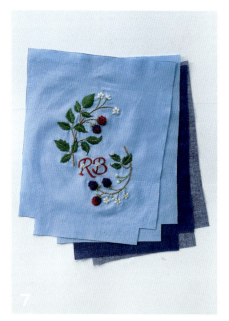
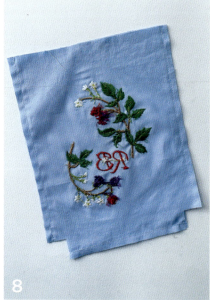
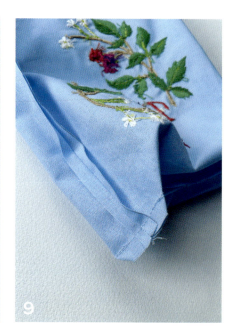
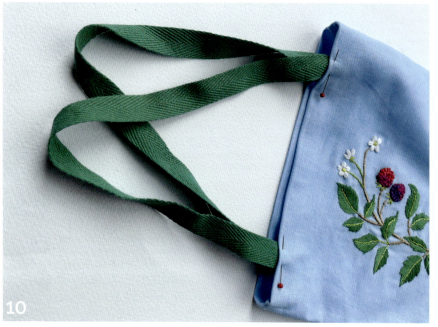
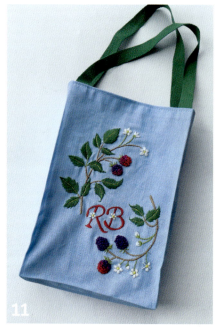

MAKING THE BAG

7. Cut out the bag around the drawn outline, including the two corner squares that will form the bag's gusset. Cut another shape from the main fabric and two from the lining fabric.

8. Stitch the side and base seams on both the main fabric and the lining with a ⅜in (1cm) seam allowance.

9. Line up the two open edges on each corner and flatten so that the seams are aligned. Pin and stitch with a ⅜in (1cm) seam allowance.

10. On the top edge of both the main bag and the lining, turn ⅜in (1cm) to the wrong side and press. Then slip the lining inside the bag, with wrong sides together. Cut the tape into two equal lengths and slip the ends between the main fabric and lining on the back and front of the bag. Pin the layers together, with the top edge of the lining just below the folded edge of the main bag.

11. Topstitch all round the top of the bag, close to the edge. Press.

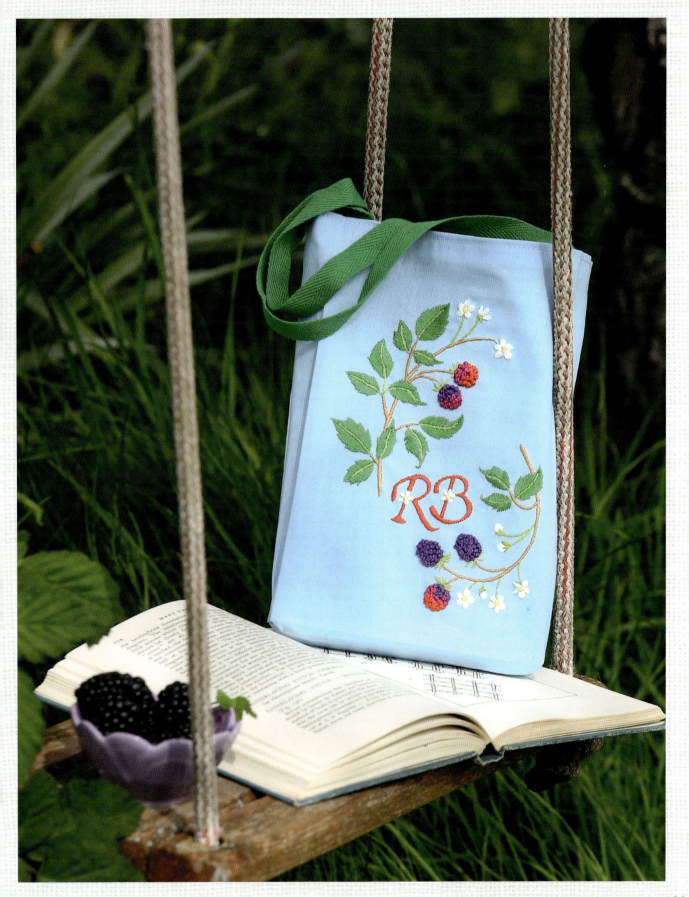

WINTER WONDERS

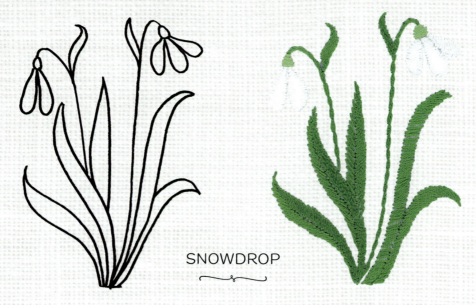

SNOWDROP

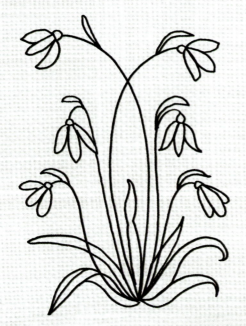

SNOWDROP GREETINGS CARD MOTIF

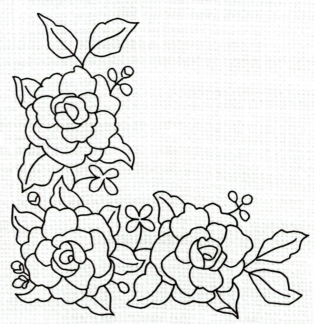

CAMELIA NAPKIN MOTIF

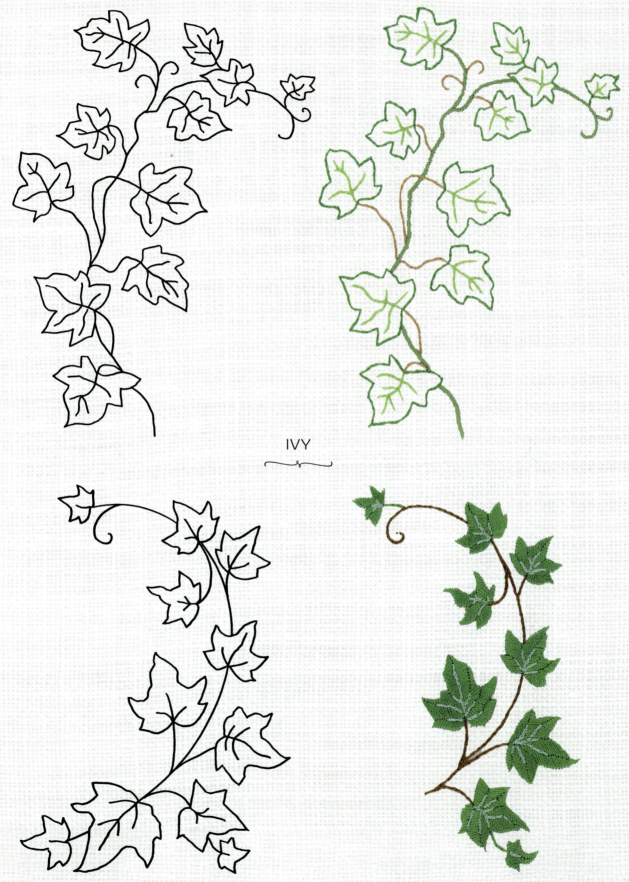
IVY

WINTER WONDERS

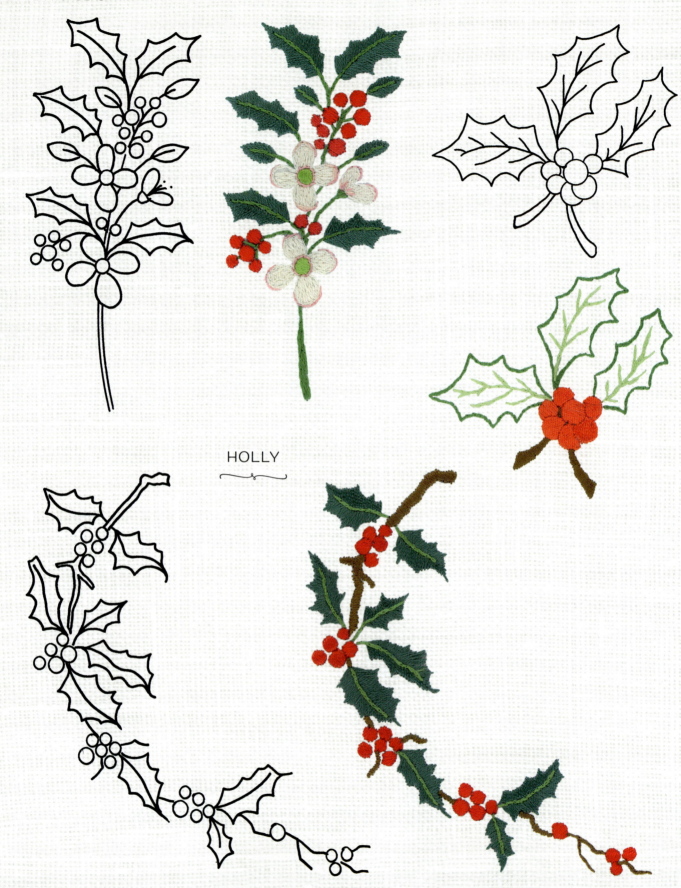

HOLLY

126

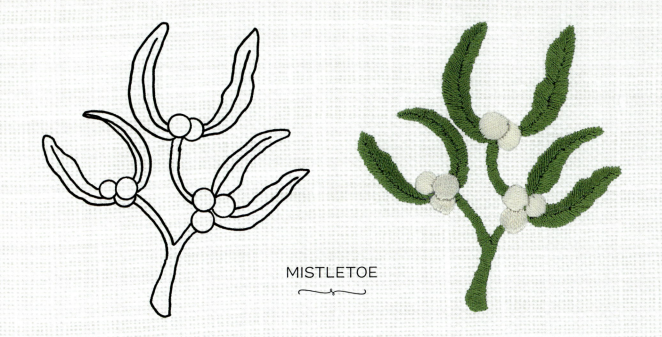

MISTLETOE

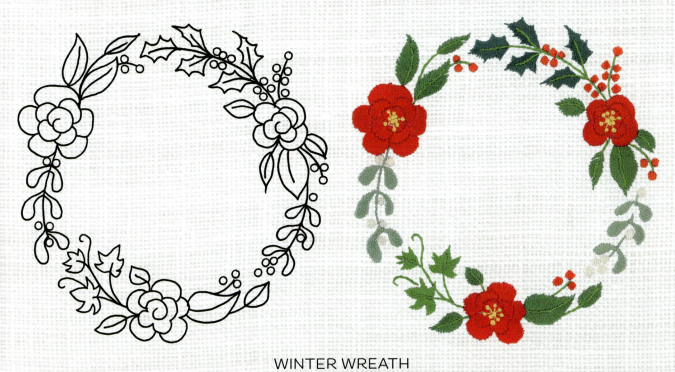

WINTER WREATH

SNOWDROP GREETINGS CARD

A small embroidered motif is relatively quick and easy to stitch – time well spent to create a greetings card for a special friend. This snowdrop would be perfect for someone with a birthday in winter or early spring.

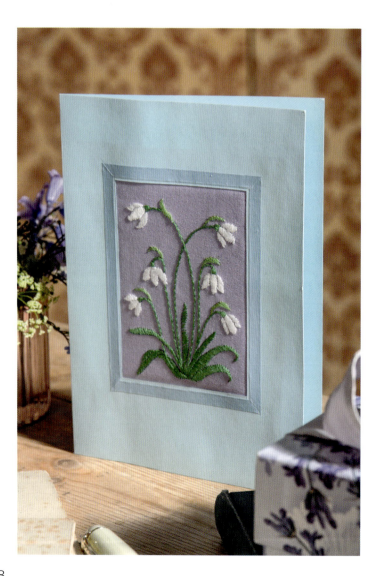

YOU WILL NEED

- Cotton fabric, at least 5 × 4in (13 × 10cm)
- DMC six-stranded thread:
 forest green 701
 sap green 906
 white B5200
- Embroidery hoop
- Crewel (embroidery) needle
- Permanent marker
- Coloured card
- Coloured felt, 3⅝ × 2⅛in (9 × 6.5cm)
- Fabric glue and spreader
- Washi tape (optional)

STITCHES USED

- satin stitch (p. 19)
- stem stitch (p. 20)

TIP

You can buy plain greetings cards with pre-cut apertures, ready to decorate with your own designs, but making your own allows you to cut the aperture to your chosen dimensions. The size of card shown here fits a standard envelope.

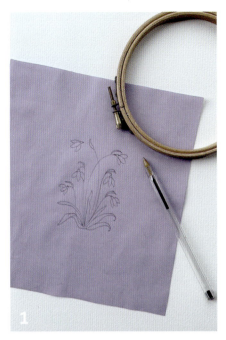
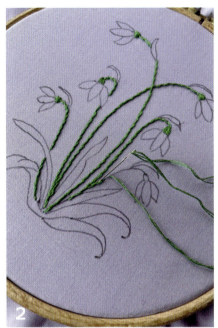
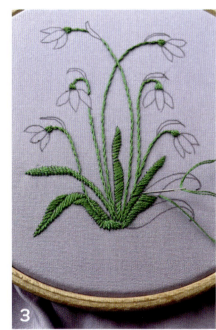
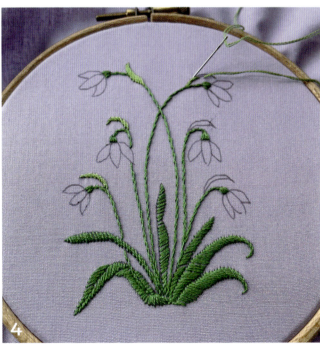
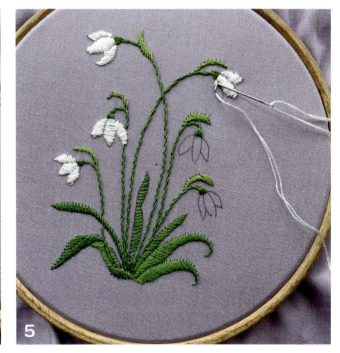

EMBROIDERING THE MOTIF

Use two strands of thread throughout

1. Trace the snowdrop greetings card motif from page 124 on to the centre of the fabric using a permanent marker, such as a ballpoint pen.
2. Place the fabric in a hoop. Using forest green 701, work the stems in stem stitch and the little bumps at the top of each stem (ovaries) in satin stitch.
3. Using the same colour, fill in the leaf shapes using satin stitch.
4. Using sap green 906, fill in the little curved shapes above each flower (the spathe) in satin stitch.
5. Fill in the flower petals in satin stitch, using white B5200. Remove the fabric from the hoop and press.

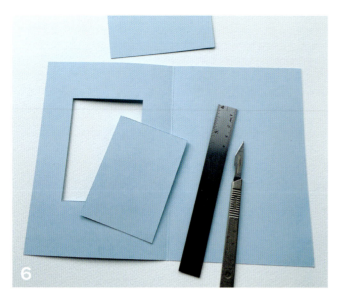
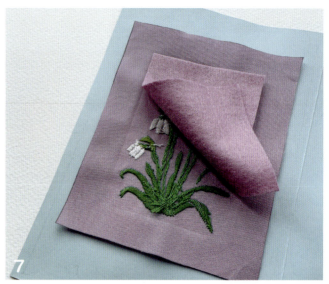
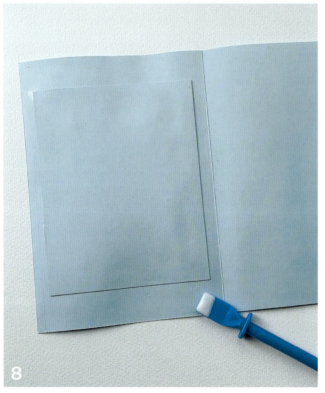
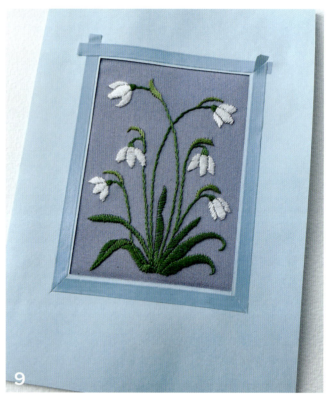

6. Cut a piece of card measuring 10 × 7in (25.5 × 18cm). Score down the centre. On the left-hand side (the inside front of the card), mark and cut out an aperture measuring 3¾ × 2¾in (9.5 × 7cm). Cut another piece of card 5¼ × 4¼in (13.5 × 10.5cm).

7. Place the embroidered piece behind the aperture; you can stick the edges to the card, if you wish. Place the felt piece on top.

8. Apply glue to the edges of the remaining piece of card and stick in place on the inside front of the card, neatly covering the fabric and felt.

9. As a finishing touch, apply strips of washi tape to the front of the card, to form a frame. Overlap the ends of the tape, then trim them to create neat mitred corners.

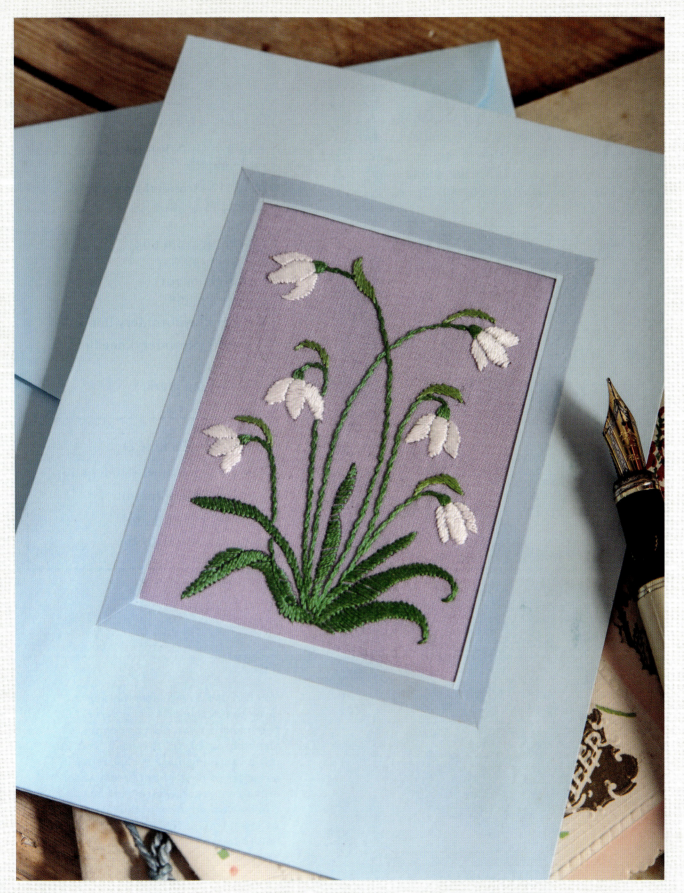

CAMELIA NAPKIN

Add a pretty flourish to your tea table with a richly embroidered napkin featuring camelias. These flowers have varieties that grow in autumn and winter, right through to spring; some plants have been known to last for hundreds of years.

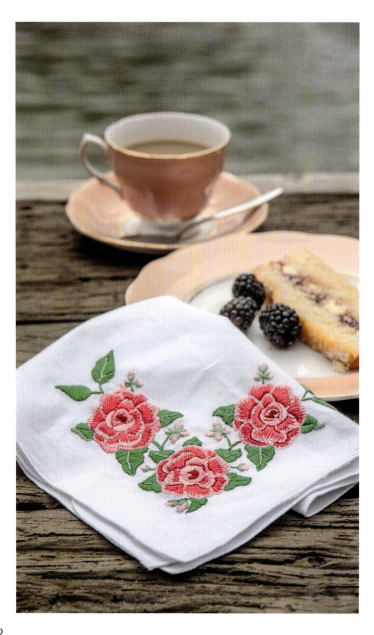

YOU WILL NEED

- White cotton or linen table napkin
- DMC six-stranded thread:
 dark cherry 3802
 deep rose 3806
 cherry blossom 605
 fuchsia pink 601
 forest green 701
 sage green 368
- 6in (15cm) embroidery hoop
- Crewel (embroidery) needle
- Ballpoint pen or vanishing marker

STITCHES USED

- long and short stitch (p. 19)
- satin stitch (p. 19)
- split stitch (p. 20)
- stem stitch (p. 20)

TIP

You can use an erasable marker to draw the design on to the corner of the napkin. If you plan to complete the embroidery fairly quickly, you can use a vanishing marker that fades in a matter of days; if not, use a water-erasable marker, where the lines can be washed away with plain water. As the lines are to be covered by embroidery stitches, however, you can use a permanent marker, such as a ballpoint pen. The choice is yours.

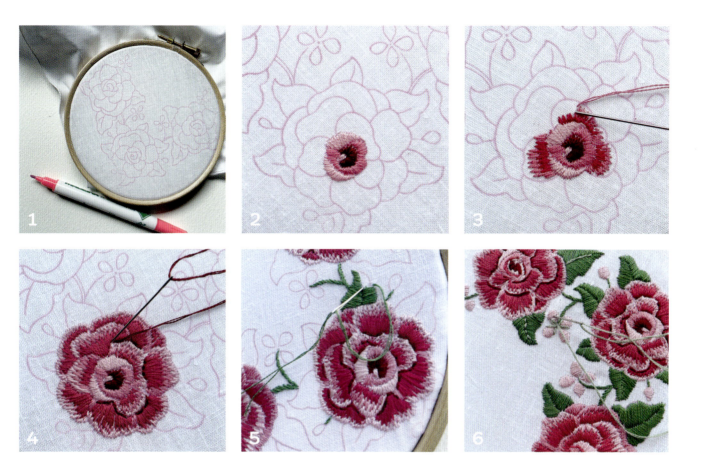

EMBROIDERING THE MOTIF

Use two strands of thread throughout

1. Using an erasable marker (or a ballpoint pen), trace the motif from page 124 on to the napkin, placing it on one corner, about 1¼in (3cm) from the edge. Place the fabric in a 6in (15cm) embroidery hoop.

2. Use dark cherry 3802 to embroider the small section in the centre, using satin stitch. Use deep rose 3806 and cherry blossom 605 for the other small centre sections.

3. Using fuchsia pink 601, deep rose 3806 and cherry blossom 605, fill in each petal with long and short stitch, working from the centre outwards and from dark to light.

4. Once the flower is completely filled, use dark cherry 3802 and backstitch to outline some of the petals to create the effect of depth. Fill in the other flowers in a similar way, using the picture of the finished embroidery as a guide.

5. Using forest green 701, embroider the stems in stem stitch and fill in the leaves with satin stitch, working the two halves of each leaf separately.

6. Using cherry blossom 605, fill in the small buds using satin stitch worked horizontally across the shape. Then, with sage green 368, add a few satin stitches worked vertically to enclose the base of each bud. With the same sage green colour, work a line of split stitch along the centre of each leaf.

Press the embroidered fabric piece on the reverse, if necessary, following the pressing guidelines on page 11.

CREATIVE IDEAS

Search junk shops and markets for old linens. They have fallen out of fashion but are still valued by people who like to set the table in a traditional style with tablecloths and napkins. Choose a napkin that is quite plain, leaving plenty of room for your embroidery. If you can't find one you like, cut a 16in (40cm) of good-quality cotton and finish the edge by hemming, or by overcasting the edge by hand or machine.

INDEX

A
anemone 112
anemone, daisies & lavender 112
apple blossom 58
aster 103
aster motif 102

B
backstitch 16
blackberry motif 113
blanket stitch 17
bluebell 115
bluebell bookmark motif 115
borage 35
bouquet cushion motif 69
bullion stitch 17
buttercups, clovers and daisies 96
buttonhole stitch 17

C
cake band motif 35
camelia motif 124
carnation 105
carnations and fuschias 104
chain stitch 18
cherry blossom 59
chive 35
chrysanthemum 103
clover 95
cow parsley 94
crocus 113
cutlery wrap motif 96

D
daffodil 24
detached chain stitch 18

E
egg cosy motif 25
exotic frame 81
exotic motifs 84, 85

F
fennel 37
fern 114
fishbone stitch 17
flower and grass border 94
flowering vine 80
fly stitch 18
forget-me-not 24, 25
foxglove 113
French knot stitch 18
fresia 72
fuchsia 105

G
grape hyacinth 26
grasses 96

H
hibiscus 84
holly 126
honeysuckle 70
honeysuckle motif 71
hyacinth 26
hydrangea 115

I
iris 45
ivy 125

L
lavender 102
lavender motif 102
lilac 72
lily 46, 47
lily motif 46
lily of the valley 25
long and short stitch 19
lupin 104

M
marigold 34
Mexican blouse motif 81
mistletoe 127

N
nasturtium 36
nasturtium motif 36
nicotiana 83

O
orchid 80
orchid motif 81
overcast stitch 19

P
padded satin stitch 19
pansy 57
pansy motif 57
passion flower 82, 83
pelargonium 106
poppy 95
poppy picnic cloth motif 95
primrose 22
primula 22
primula ring 23

R
rose 71
running stitch 16

S
satin stitch 19
snowdrop 124
snowdrop greetings card motif 124
split stitch 20
split stitch filling 20
stem stitch 20
straight stitch 20
sunflower 44
sweet pea 68
Sweet William 56
Sweet William baby dress motif 56

T
tablecloth motif 23

V
violets needle case motif 47

W
wild rose 68
winter wreath 127
woven wheel stitch 18

ACKNOWLEDGEMENTS

Many thanks to Jonathan Bailey for asking me to write this book; to Tom Kitch for his patience and organizational skills; to Nicola Hodgson and Alexis Harvey for editing the text so meticulously; to Roddy Paine for photographing the finished projects so beautifully; and to Emily Hurlock for designing such attractive pages.

Thanks also to my Mum for teaching me to sew in the first place, to my daughters Lillie and Edith for their advice and input, and my sister Lisa for helping to source so many lovely old linens, the perfect material for embroidered embellishments.

First published 2024 by
Guild of Master Craftsman Publications Ltd,
Castle Place, 166 High Street
Lewes, East Sussex, BN7 1XU, UK

Text © Susie Johns, 2024
Copyright in the Work © GMC Publications Ltd, 2024

ISBN 978-1-78494-681-4

All rights reserved

The right of Susie Johns to be identified as the author of this work has been asserted in accordance with the Copyright, Designs and Patents Act 1988, sections 77 and 78.

No part of this publication may be reproduced, stored in a retrieval system or transmitted in any form or by any means without the prior permission of the publisher and copyright owner.

This book is sold subject to the condition that all designs are copyright and are not for commercial reproduction without the permission of the designer and copyright owner.

While every effort has been made to obtain permission from the copyright holders for all material used in this book, the publishers will be pleased to hear from anyone who has not been appropriately acknowledged and to make the correction in future reprints.

The publishers and author can accept no legal responsibility for any consequences arising from the application of information, advice or instructions given in this publication.

A catalogue record for this book is available from the British Library.

Publisher: Jonathan Bailey
Production Director: Jim Bulley
Senior Project Editor: Tom Kitch
Design Manager: Robin Shields
Designer: Emily Hurlock
Editors: Nicola Hodgson and Alexis Harvey
Stylist: Susie Johns
Photographer: Roddy Paine
Technical Illustrator: Martin Woodward

Photograph on page 10 (top right) © Shutterstock/New Africa

Colour origination by GMC Reprographics
Printed and bound in China

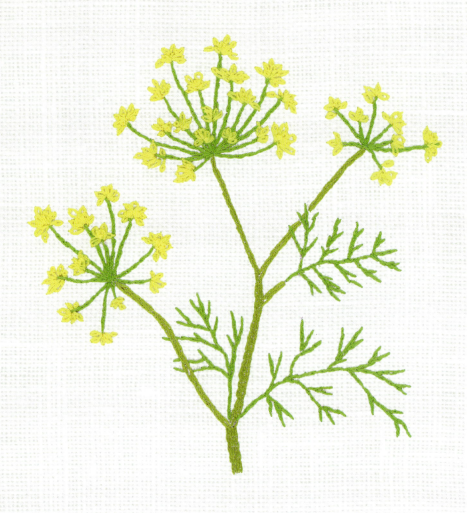

To order a book, contact:

GMC Publications Ltd
Castle Place, 166 High Street,
Lewes, East Sussex BN7 1XU, UK

Tel: +44(0)1273 488005

www.gmcbooks.com